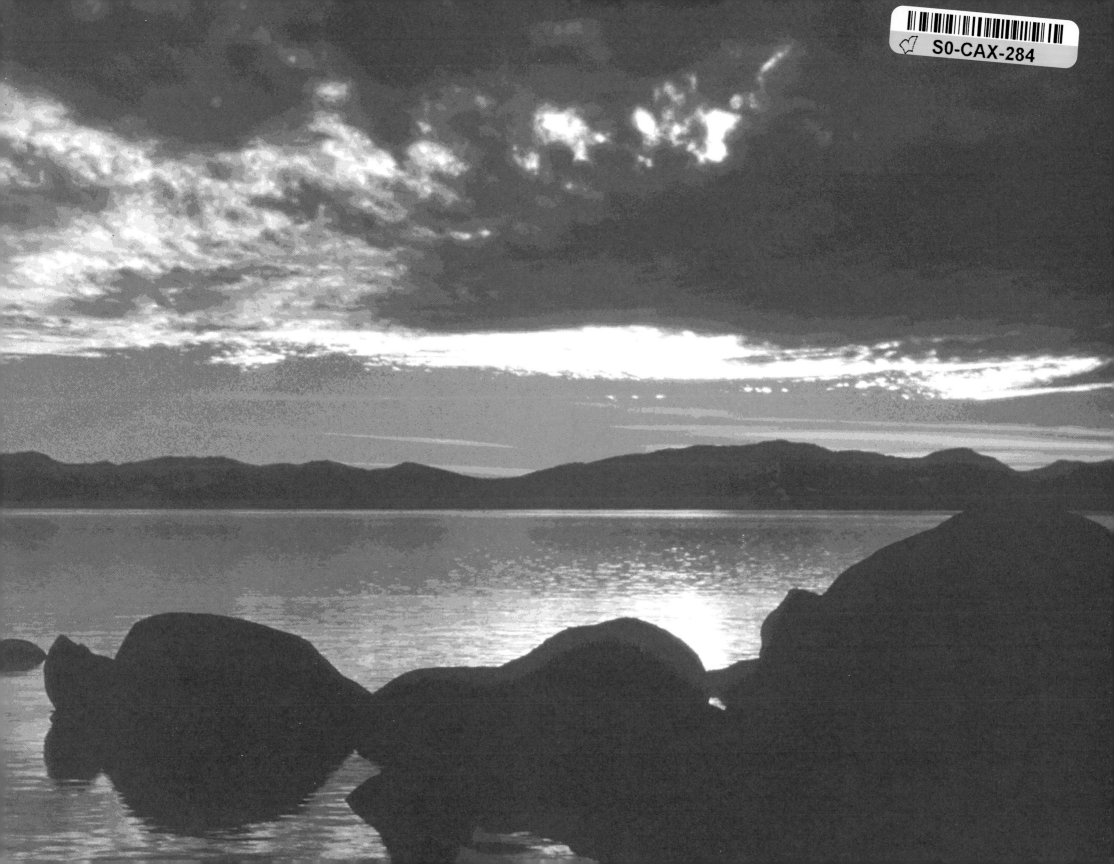

Larry Pesetski

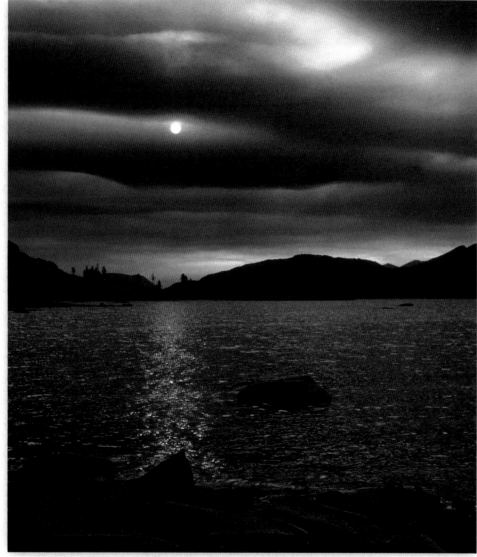

1. *Sunrise over Lake Aloha*

A Journey to
LAKE TAHOE
& Beyond

To Phil & Amber
I hope
you enjoy
these
images
Best wishes
Larry Pesetski

A Journey to
LAKE TAHOE
& Beyond

By Larry Pesetski

Published by
Sierra Vista Publications, Crystal Bay, Nevada

First Edition
Published in ©2005 FL Wright

Printed in China
Designed by Andrew D. Garcia
Photographs by Larry Pesetski

For Information:
Sierra Vista Publications
P.O. Box 186 Crystal Bay, Nevada 89402
E-mail: alpinesports@earthlink.net

Library of Congress Cataloging-in Publication-Data
80993400000008397789
Pesetski, Wright, Garcia

ISBN 0-9711314-8-1

Introduction

Although it may be true that "A rose by any other name would smell as sweet," we are probably grateful that the lovely rose was not saddled with an outlandish moniker such as "stanky panks."

Likewise, for all those who have been inspired by the beauty of Lake Tahoe, we can be thankful that the name "Lake Bigler" did not stick. Actually, Lake Tahoe – in its brief Anglo history – has seen several name changes. The explorer John C. Fremont is given credit as being the first white man to lay eyes on Lake Tahoe. In 1844, from the top of what is now called Red Lake Peak near Carson Pass, Fremont saw the large shimmering water of indigo blue several miles to the north. He called it "Lake Bonpland," naming it after an eminent French botanist. However, the topographer on his expedition, Charles Preuss, labeled it "Mountain Lake" on the maps he charted.

No one seemed to be too interested in Lake Bonpland or Mountain Lake immediately after Fremont's visit. The California gold fields were much farther west, and pioneers of the time were more interested in profit than scenic beauty. Then came the discovery of silver in Nevada's Comstock Lode in 1859, and miners migrated from the California gold fields through the Lake Tahoe basin. Soon, the lake became important for its heavily forested shores. Lumber was needed for the boomtowns of Nevada and later for the building of the transcontinental railroad, which would pass further north of Lake Tahoe near the route of the Donner Party.

Now that the lake had become an important destination or landmark, it needed an agreed upon name. The local inhabitants had unofficially been calling it "Tahoe," based on the Washoe Indian word for "big water." Not everyone was happy with the name "Tahoe," and there was strong sentiment to name the lake after California governor John Bigler, who had led a rescue party in the winter of 1852 to bring out snowbound emigrants trapped near the lake. In fact, correspondence and written records of the 1860's indicate an identity problem. Oftentimes, the lake is called "Lake Bigler" or when it is called "Lake Tahoe" the word "Bigler" follows in parentheses. In the 1860's ex-Governor Bigler came out as a Confederate sympathizer and alienated many of the residents of Lake Tahoe who were pro-Union and, thus, wanted the name of the lake to remain "Tahoe." Of course, white people often butcher the pronunciation of Native American words. According to Native American linguists the Washoe word for lake was "Da-ow-a-ga." This, I suppose, was close enough to "Tahoe" for the white man. A grassroots campaign was started at the lake to eradicate "Bigler" as the name. Thus, the cumbersome process was started towards giving this breathtaking lake – 22 miles long and 12 miles wide – a permanent name. Indeed, it wasn't until an act of the California State legislature in 1945 that "Lake Bigler" was officially declared "Lake Tahoe."

Perhaps the name itself is only important to people who have been captivated by the lake's spell. The lake and its beauty are timeless, geologic; to stick an Anglo name on it when the white man has been only an infinitesimal part of its history would seem inappropriate, even arrogant. The Washoe Indians who were the first human inhabitants of Lake Tahoe have a prior claim to the lake. The shores of Lake Tahoe have centuries of Washoe history. The Indians came to the lake primarily in the summer and fall to fish for the cutthroat trout and gather the seeds of the native plants. They also traded pine nuts and obsidian for the acorns and other products of the Western Sierra Indians. Unlike the white man, they left little but footprints, and only lately has the white population realized just how devastating has been the impact of their brief encounter with Lake Tahoe.

Is it still possible to view Lake Tahoe as the Indians did a thousand years ago?

Many visitors to Lake Tahoe notice the lake and mountains as merely a scenic backdrop out the windows of their SUVs. They are in a hurry to get to the gambling casinos or to the ski resorts. There is no denying the urbanization of Lake Tahoe and the traffic and noise and blight that it has caused. The encroachment of civilization has taken away much of the pristine beauty of the area. Yet, the water of Lake Tahoe still possesses a clarity that will enchant anyone who wanders its shores by foot or by kayak. The burning sunsets over the western mountains that ring Lake Tahoe are still spectacular. Emerald Bay is still a precious jewel of cobalt blue. Find yourself alone on the Tahoe Rim Trail and you can view this "mountain lake" – this "big water" – as the Washoe Indians did or with that same sense of awe that John C. Fremont experienced.

In fact, a short hike into the 64,000 acres of Desolation Wilderness brings out the explorer in us. Directly west of Emerald Bay, "Desolation" contains 75 miles of trails and more than 100 lakes. Several peaks rise more than 9,000 feet in altitude – 3,000 feet above the shore of Lake Tahoe. The explorer in us delights in the spectacle of tumbling snowmelt streams amid shining granite that has been scoured by ancient glaciers. We lose our sidewalk gait as we stop to gaze at wildflower gardens or as we pause to toss rocks into deep blue alpine lakes. Our encounters with fellow explorers are, paradoxically, more civilized than our passings – by in civilization. We take the time to look one another in the eye, and our voices ring true when we say, "Beautiful day, isn't it!" Maybe the purity of the water or the clarity of the air has something to do with it. Or as Mark Twain said, "To obtain the air the angels breathe, you must go to Tahoe."

Perhaps George Wharton James is the one who got the name of the lake right. He claimed that the correct pronunciation is one syllable – Tao. Lake Tao – where your soul can find inner peace and exist in harmony with Nature.

Bob Miller – *October 2002*

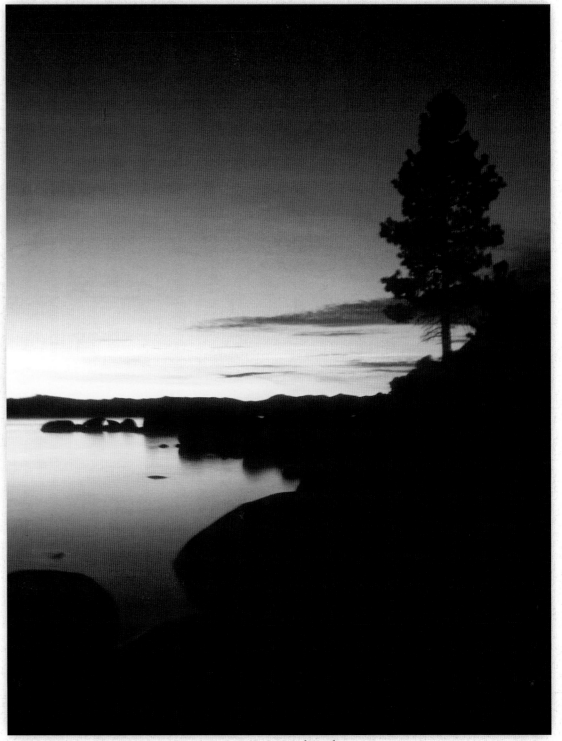

2. *Sunset at Sand Harbor*

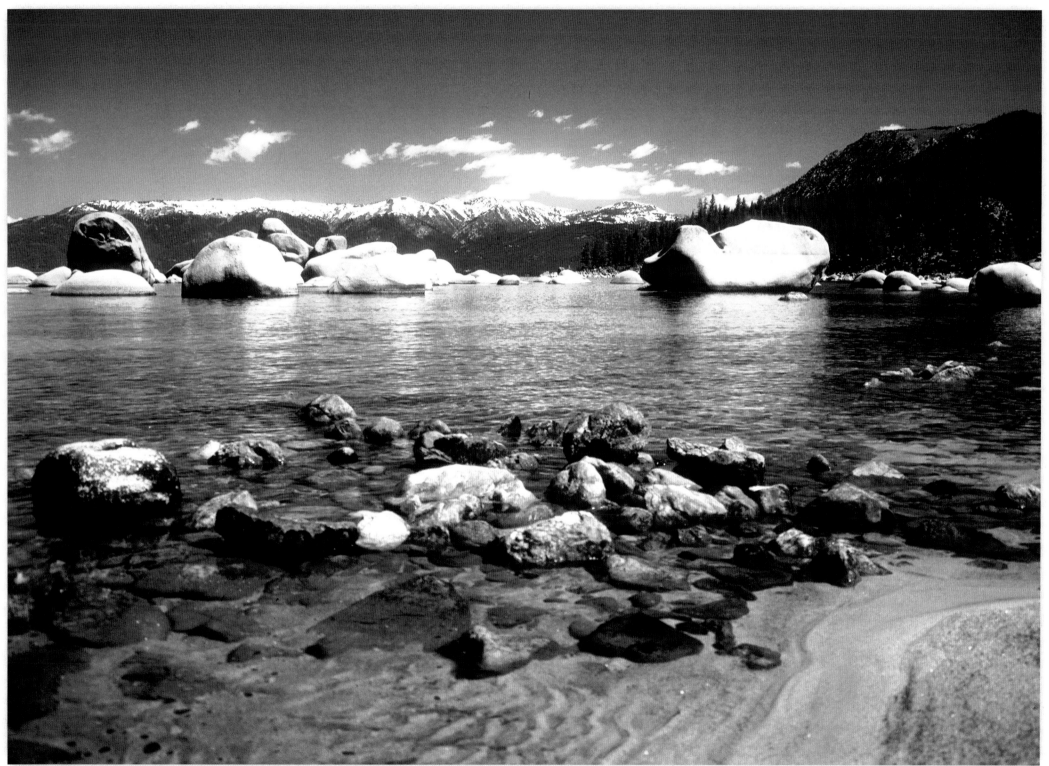

3. *East shore of Lake Tahoe*

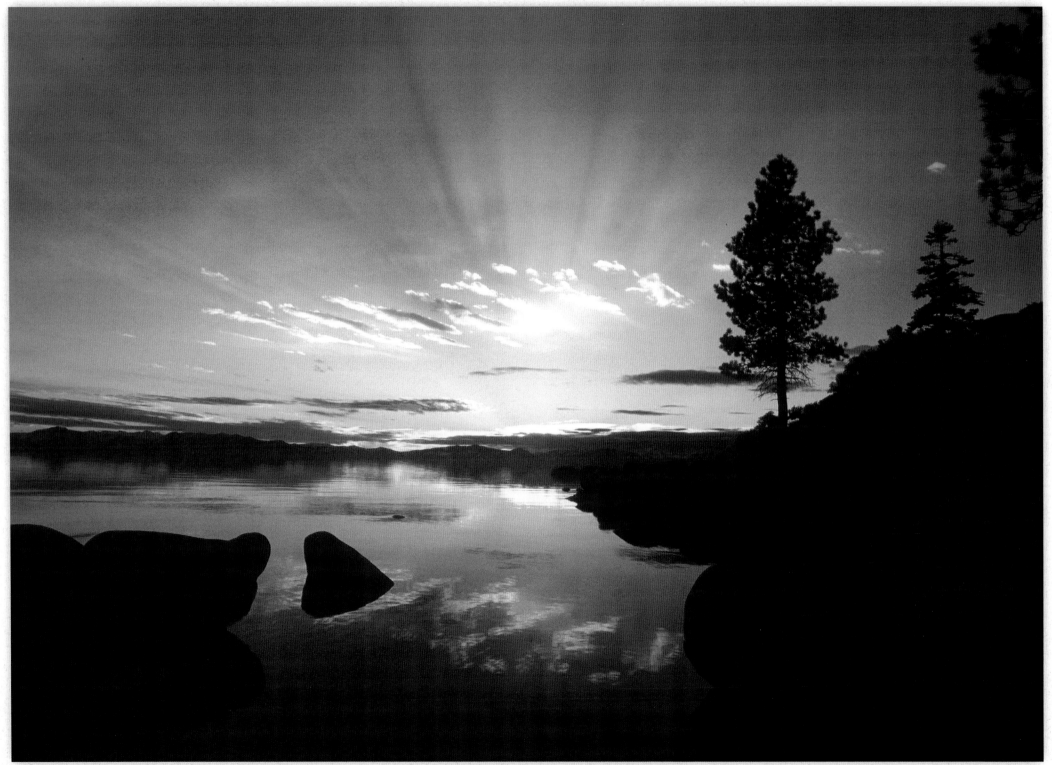

4. *Sunset at Sand Harbor*

5. *Fall color in Desolation wilderness* ▶

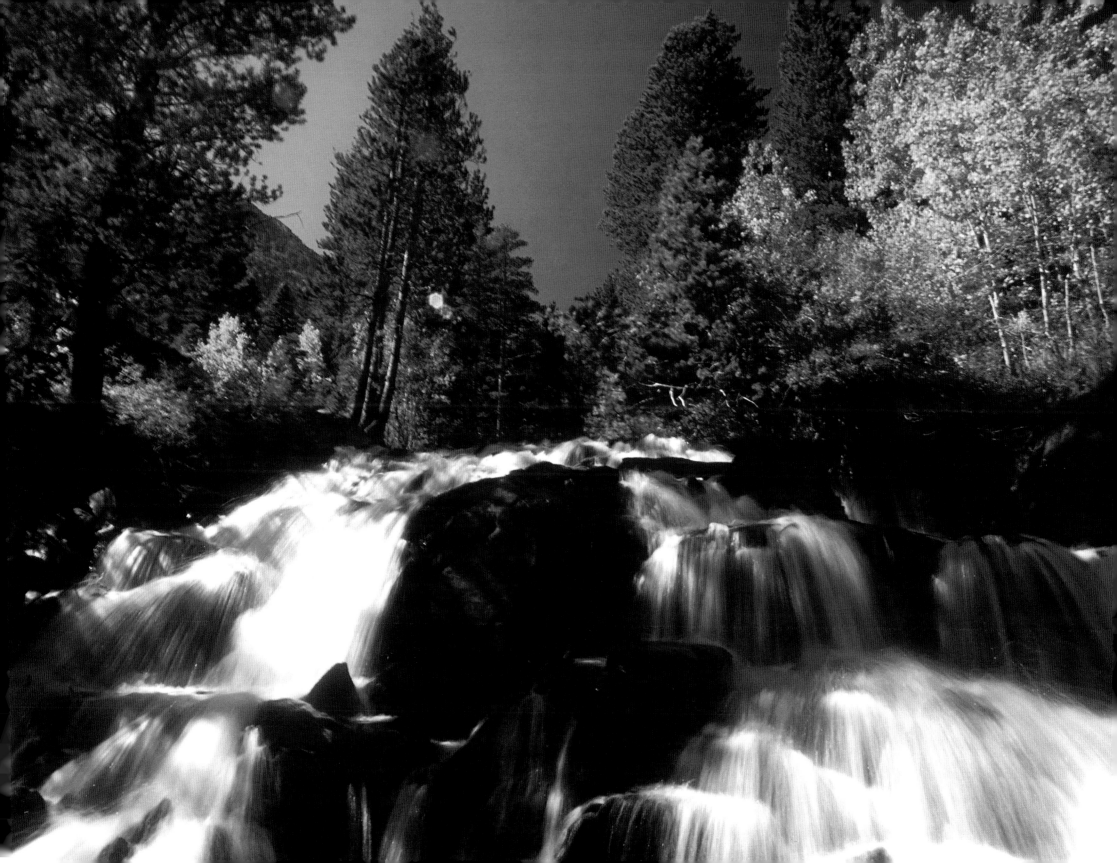

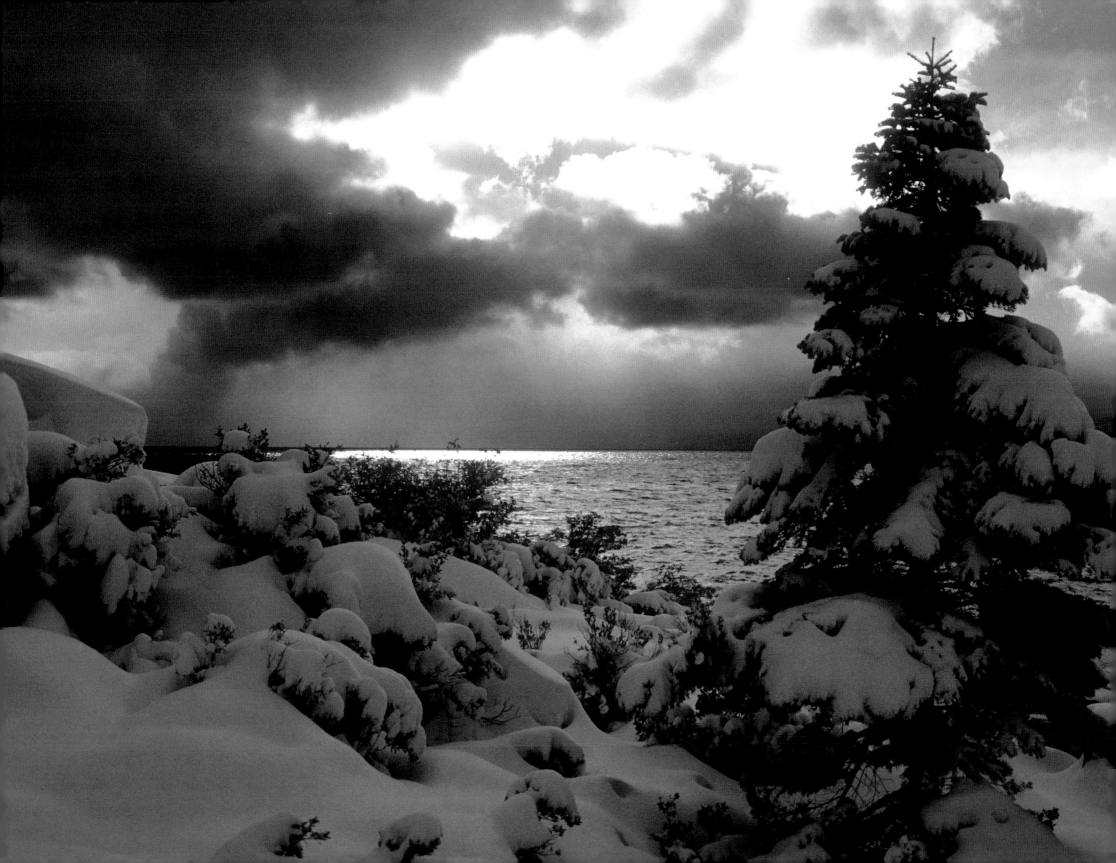

Journey to Lake Tahoe and Beyond

The Oxford Dictionary defines a journey as "an act of going from one place to another," or "a distance traveled in a specified time." Since 1962, I have made my own journey to the lake the Washoes call "Da-ow-a-ga." Each time the magic of the area truly moves me to another place not just in a physical sense but also in an emotional and mental way. The beauty and awe-inspiring vistas of Lake Tahoe continue to be a source of refreshment and renewal even after 40 years worth of journeys.

I have tried to share with you some of the sights and moments from this distance traveled. From the Great Reno Balloon Race to the moonsets and sunsets. From the seasons of Tahoe to the profusion and beauty of its wildflowers to the area that lies beyond its shores. Like the lyrics of a popular song these all are memories now in the corner of my mind. Leo Buscaglia, the world famous psychologist who lived at Glenbrook on Lake Tahoe, once said, "The greatest gift you can give to another is simply to say look at that sunset and share a moment of human emotion with another." If my images move you emotionally the way they did me as I saw them unfold, then I am happy. Please enjoy them and allow them to create a journey for you.

Larry Pesetski – *October 2005*

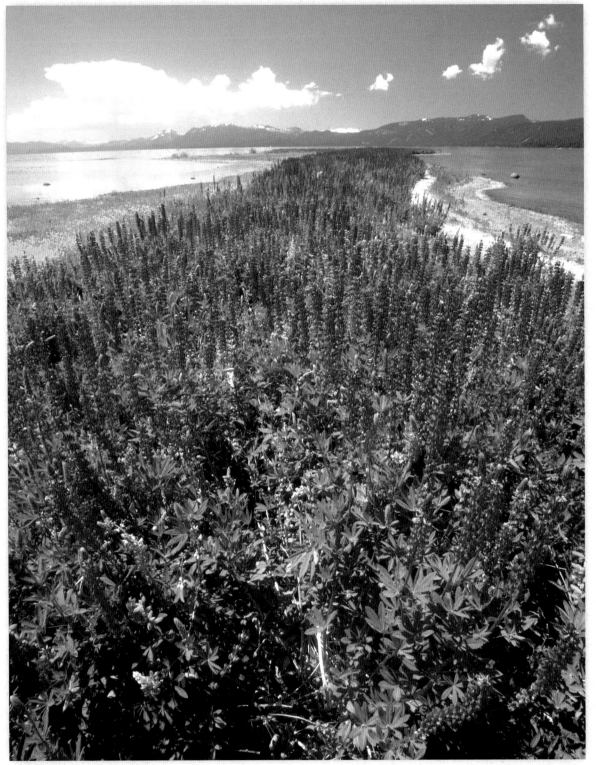

◄ **6.** *Clearing storm at Visitors' Overlook on Highway 28*

7. **Wildflowers: Tahoe City**

Tahoe and Beyond

The lakes and valleys, streams and ridges, mountaintops and recesses of the land around Tahoe offer to the visitor journeys so diverse and unique that you would have to spend a lifetime exploring them and still you would never be able to experience them all. To journey into this country is to allow yourself to feel the natural order of things. To put a backpack or a daypack on your back and hiking shoes on your feet and allow Tahoe and its friends to move you away from civilization and into the far reaches offers you a sense of renewal that can be found nowhere else. The secrets of the back country are there if one allows the journey to happen. You can be so completely alone in the wilderness that the silence and beauty engulf you. Time seems to stand still and the fog of civilization lifts. The historian Frederick Jackson Turner calls this the frontier thesis, that the environment will transform us and regenerate our unique character if we only allow the journey to unfold.

Tahoe asks nothing of us but a little time and effort to make our spirits soar. It seems such a small price to pay for such rich and life-altering dividends.

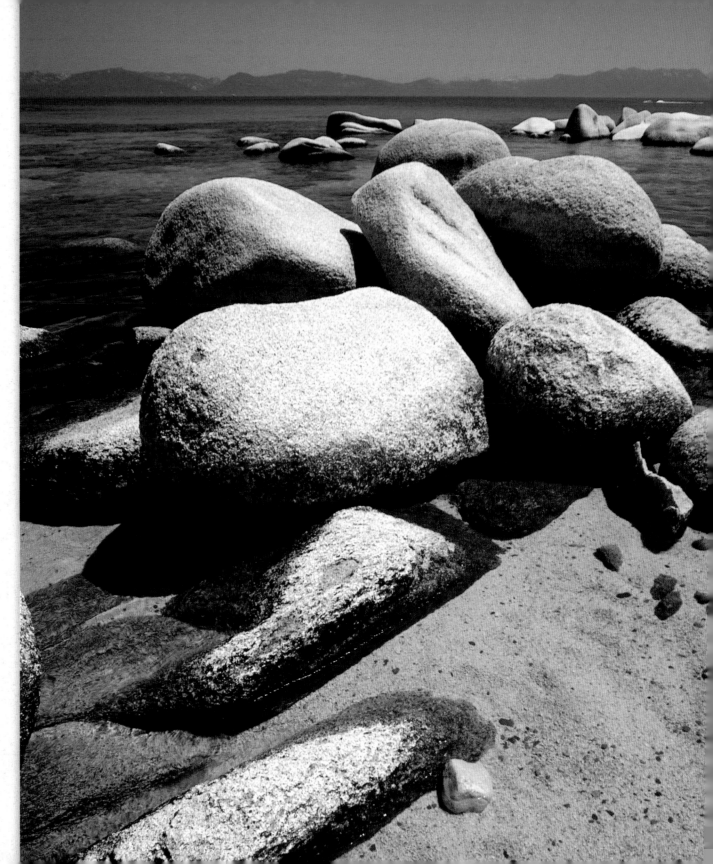

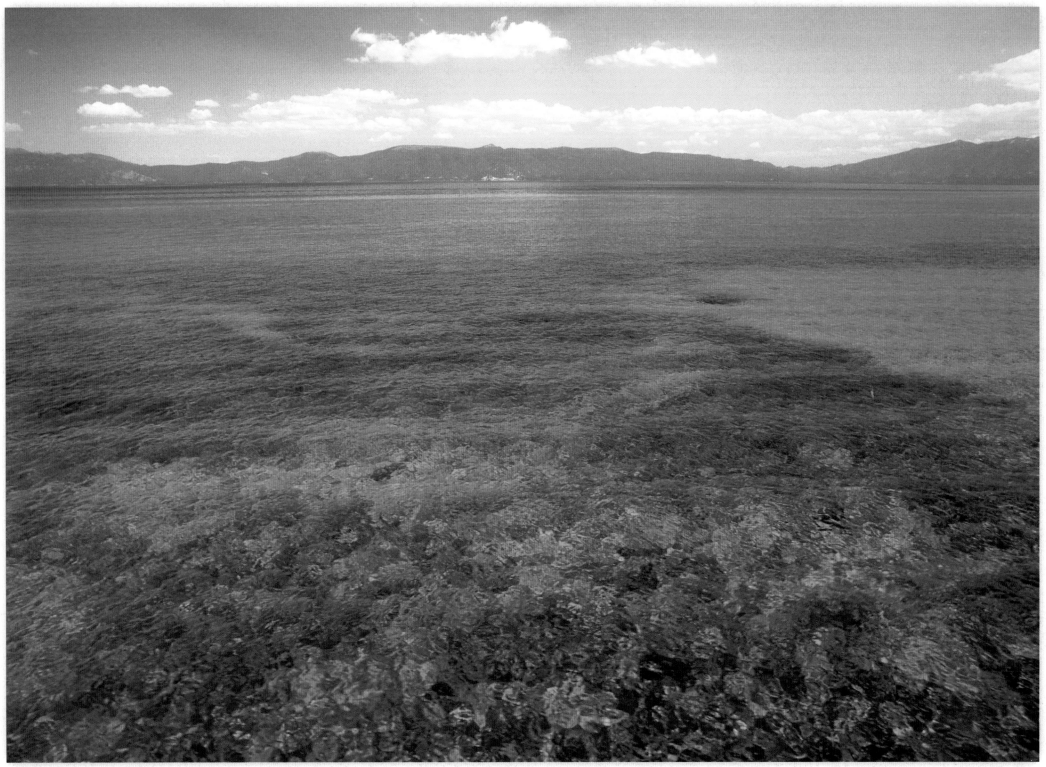

◄ **8.** *Hidden Beach*

9. *Lake Tahoe mosaic on the east shore*

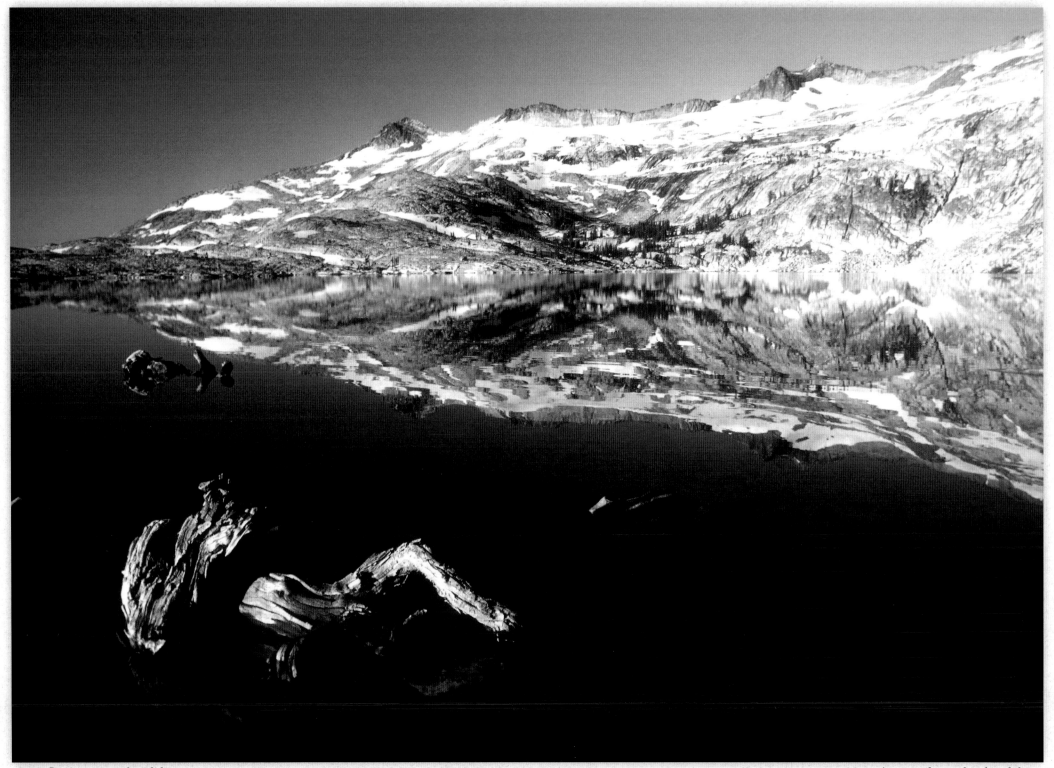

10. *Reflections on Lake Aloha*

11. *Mosquito Pass beyond Lake Aloha* ▶

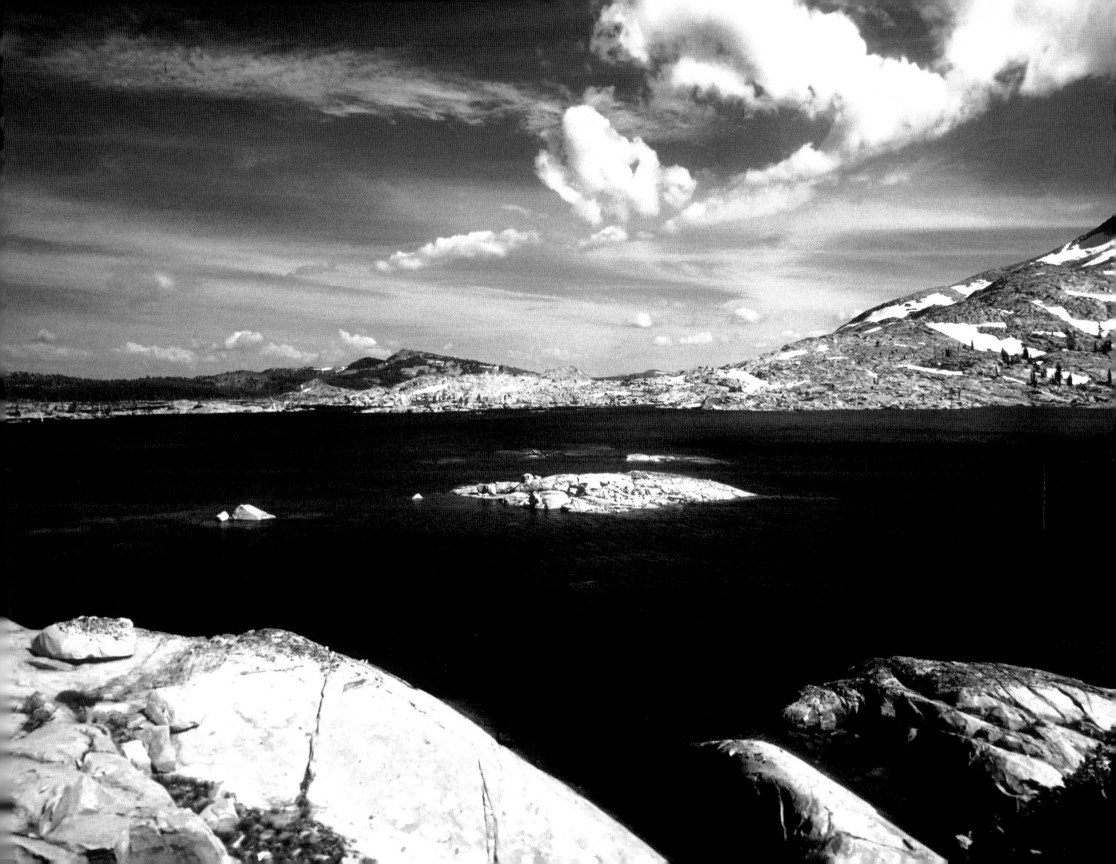

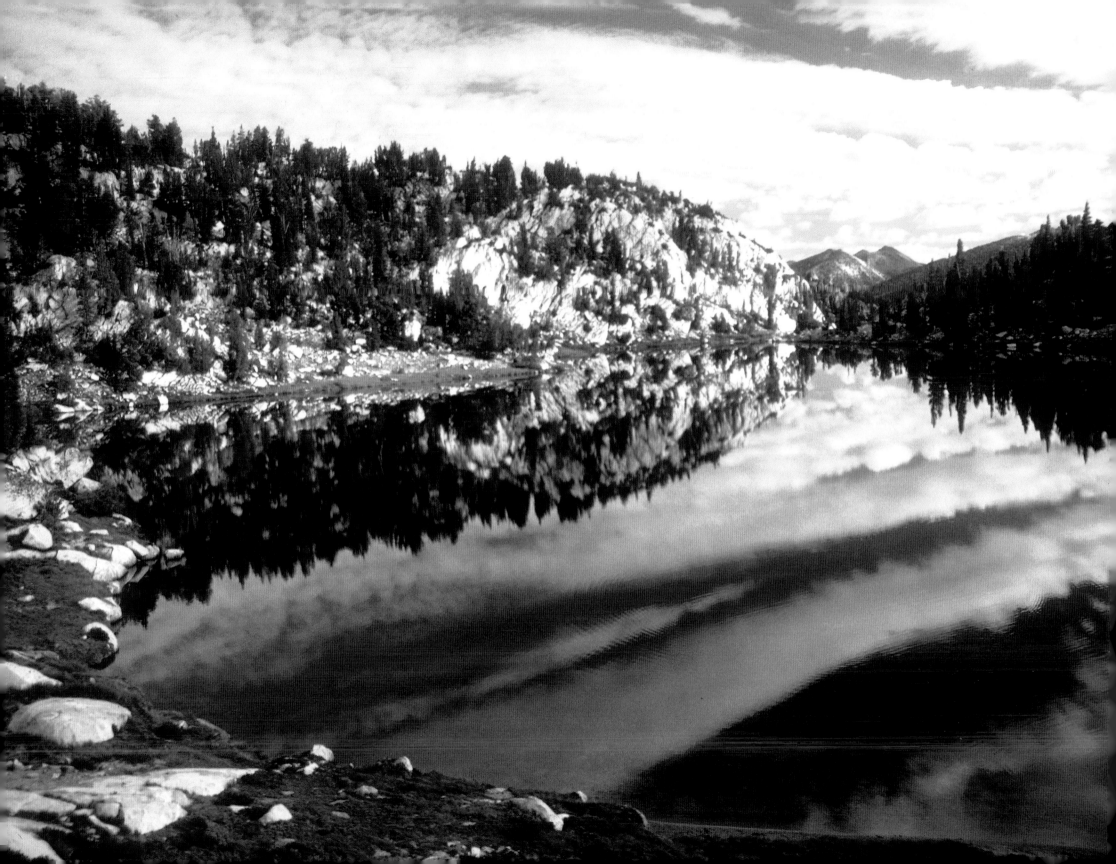

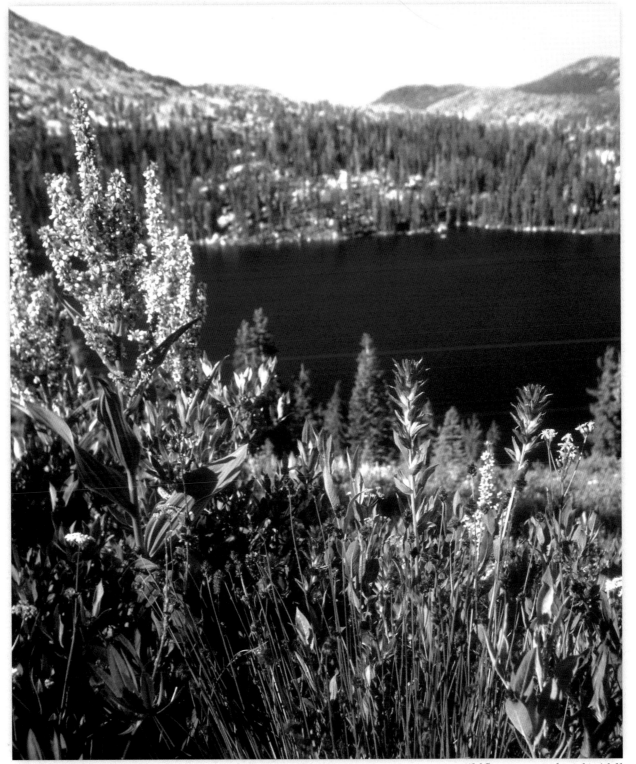

◄ 12. *Sunrise reflections in Desolation Wilderness*

13. *Wildflowers at Lake Schmidell*

17

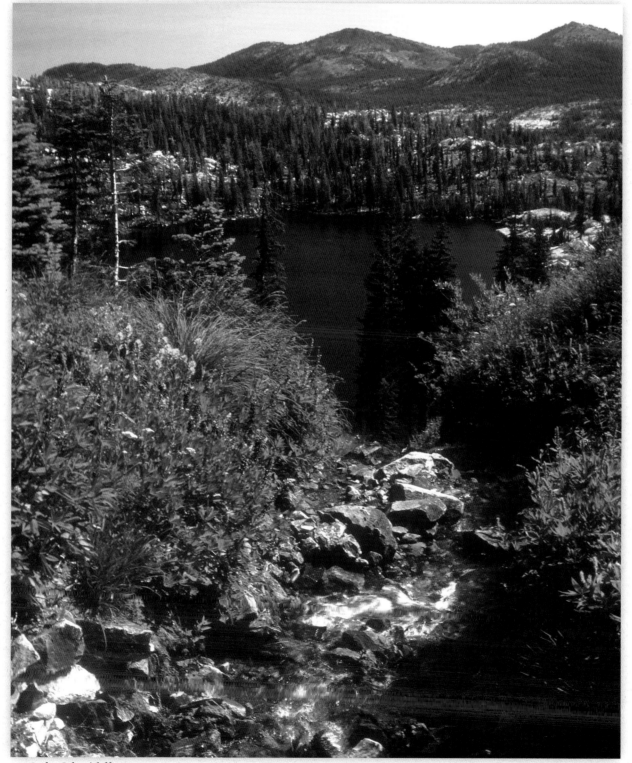

14. *Lake Schmidell*

15. *Lake Tahoe at Hidden Beach* ▶

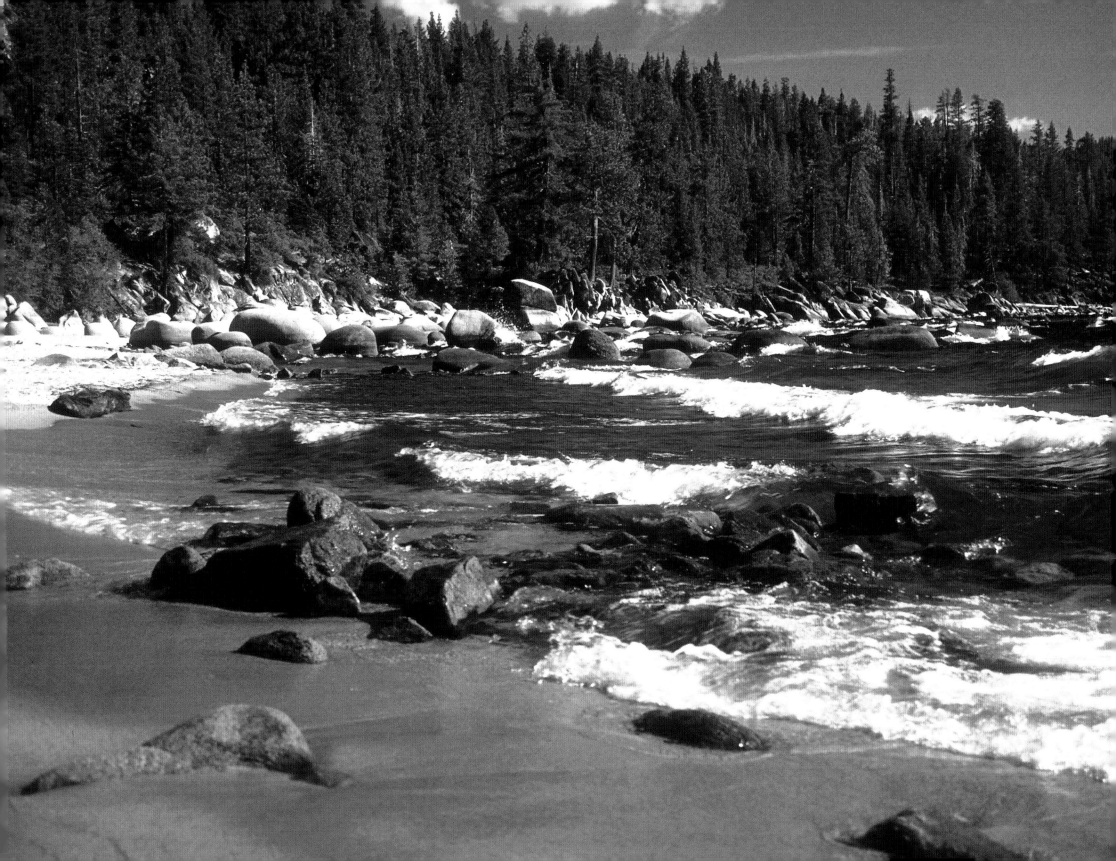

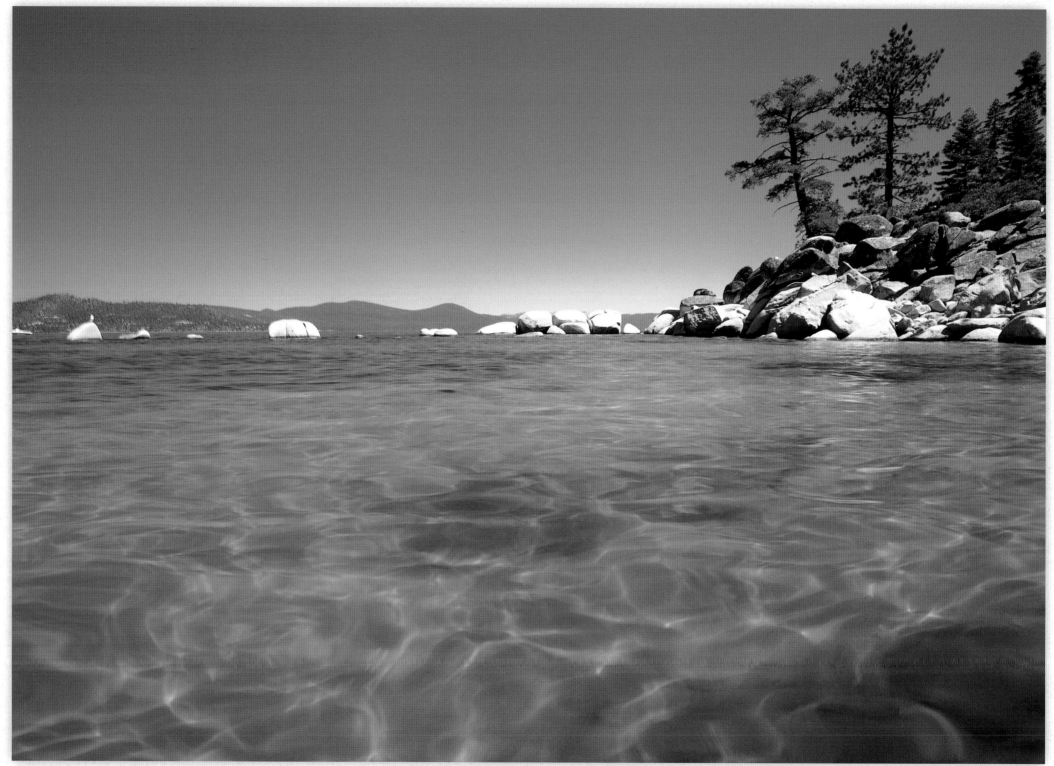

16. *Emerald Waters: East shore Lake Tahoe*

17. *Doris Lake and Rockbound Pass* ▶

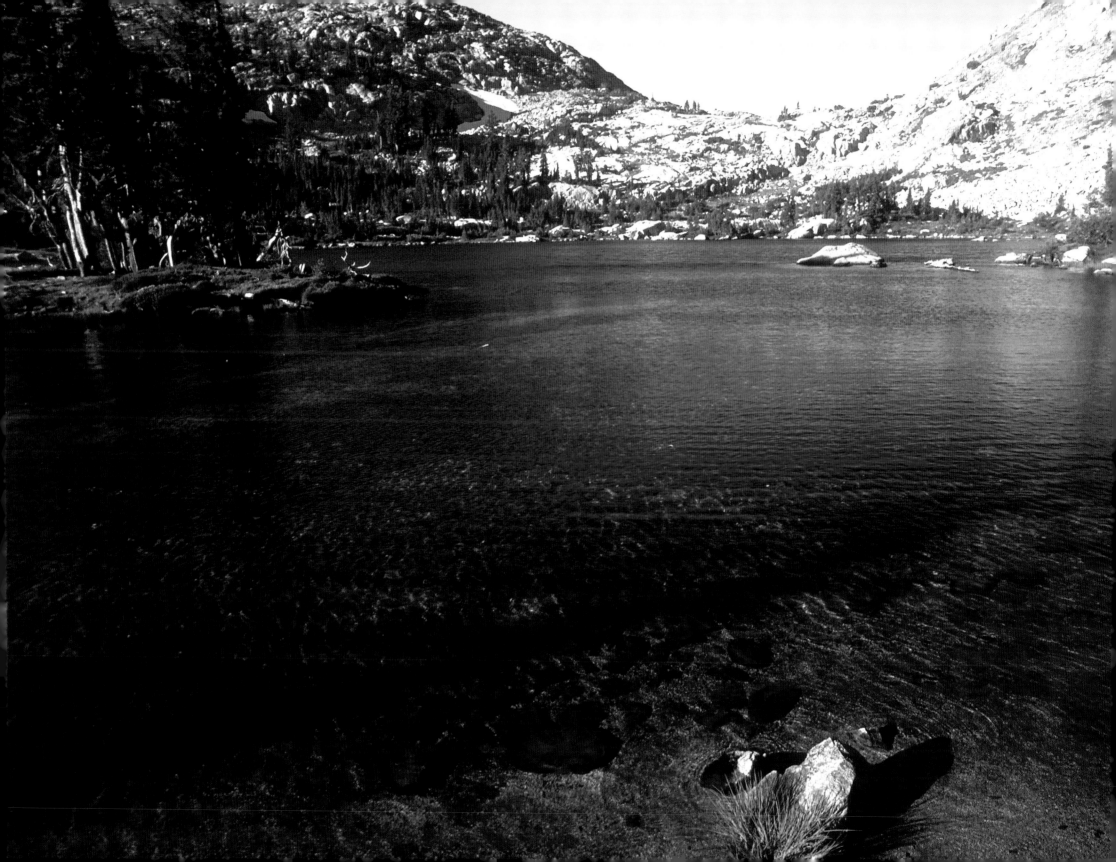

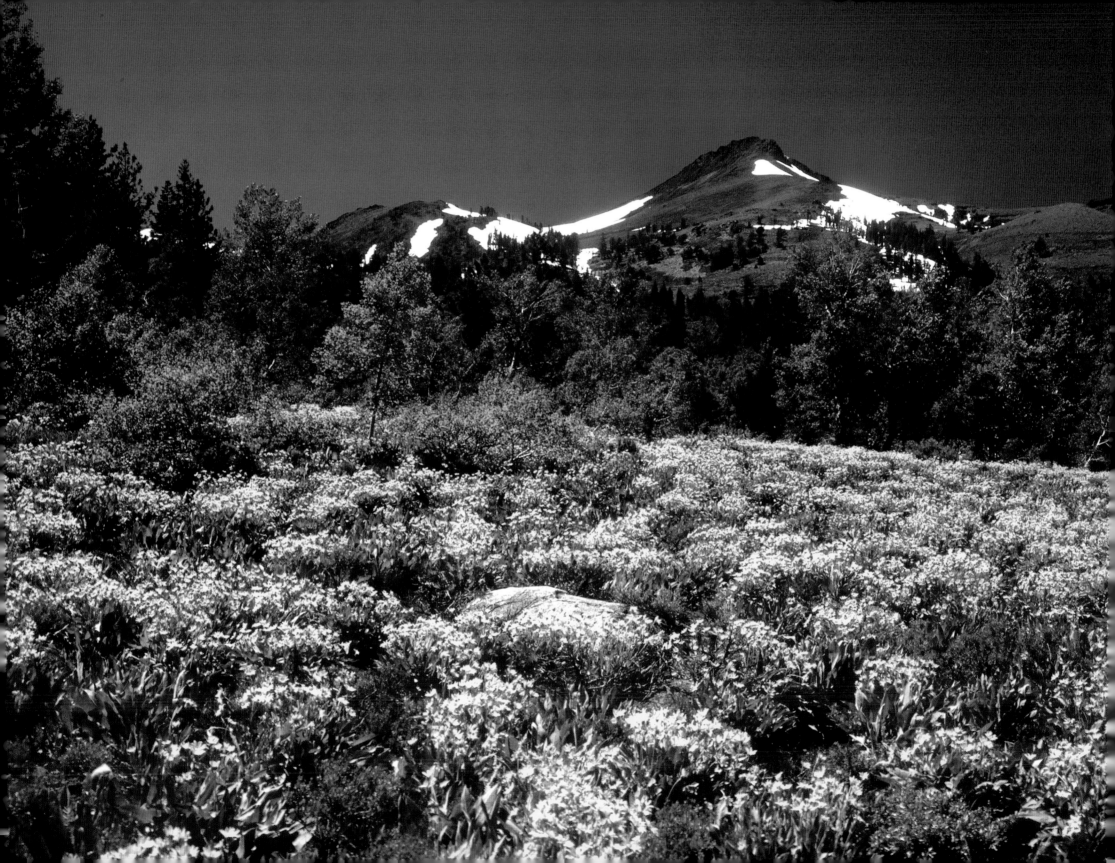

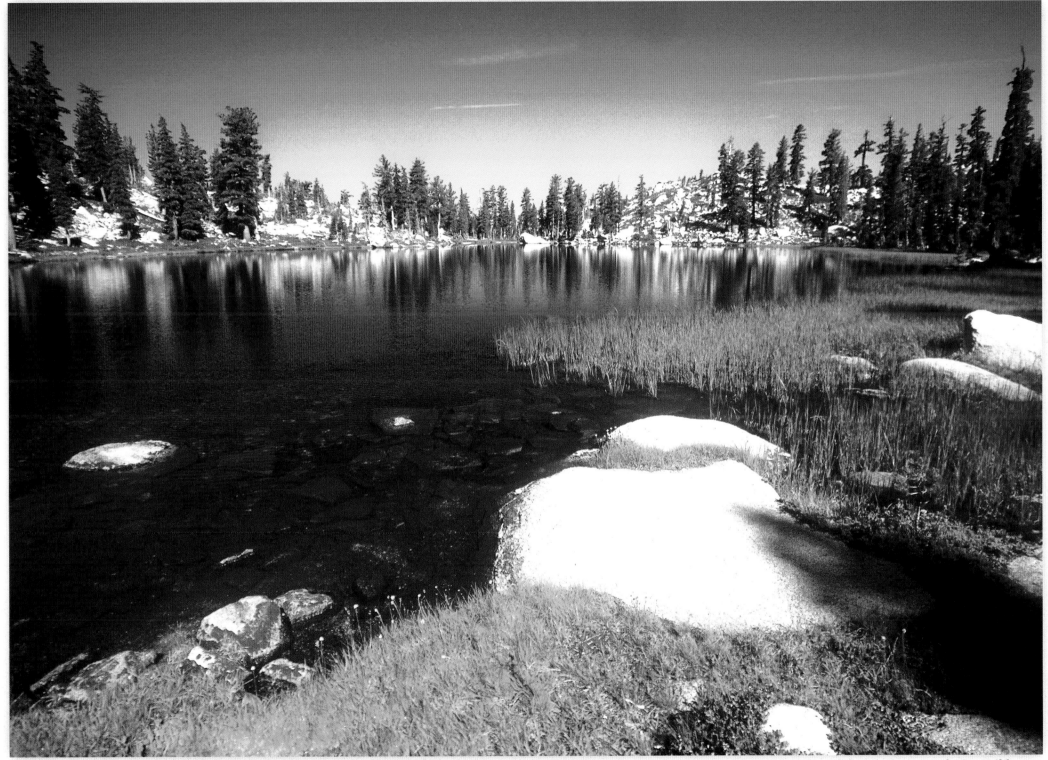

◄ **18.** *Stevens Peak and Hope Valley*

19. *Doris Lake in Desolation Wilderness*

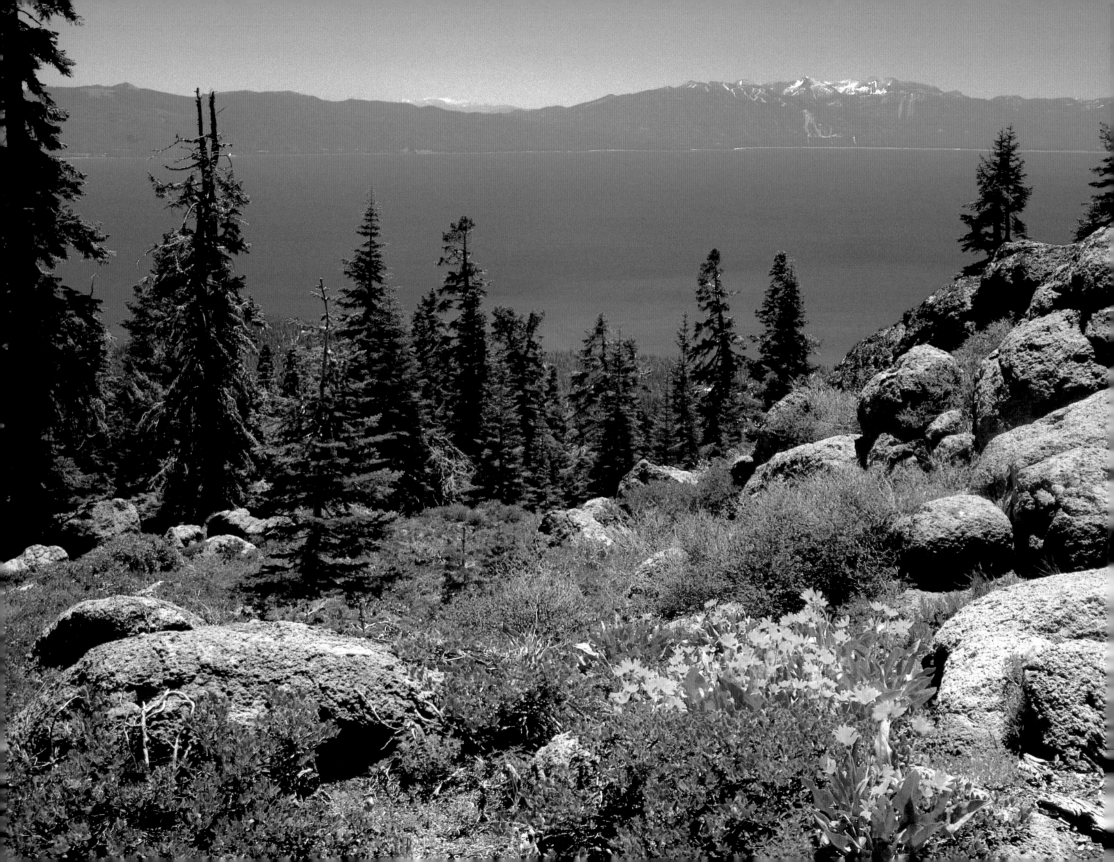

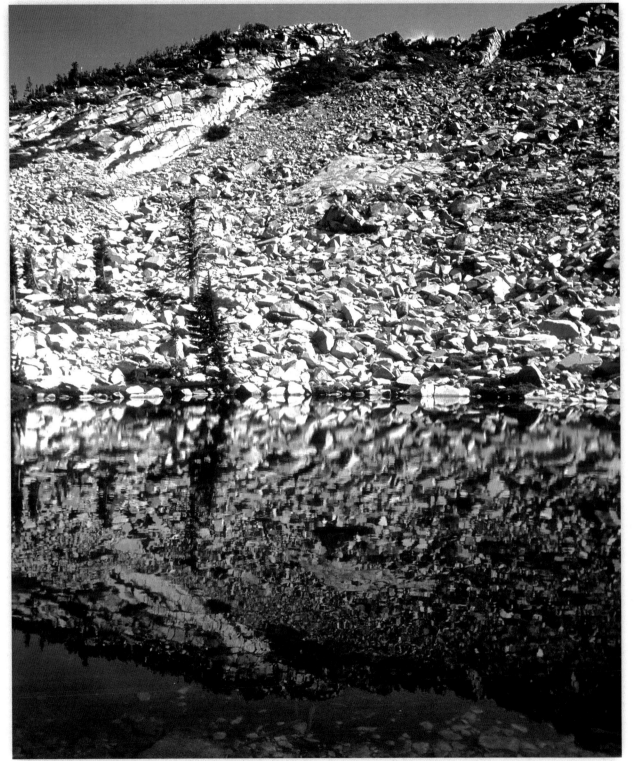

◄ **20.** *Tahoe Rim Trail*

21. *Hemlock Lake in Desolation Wilderness*

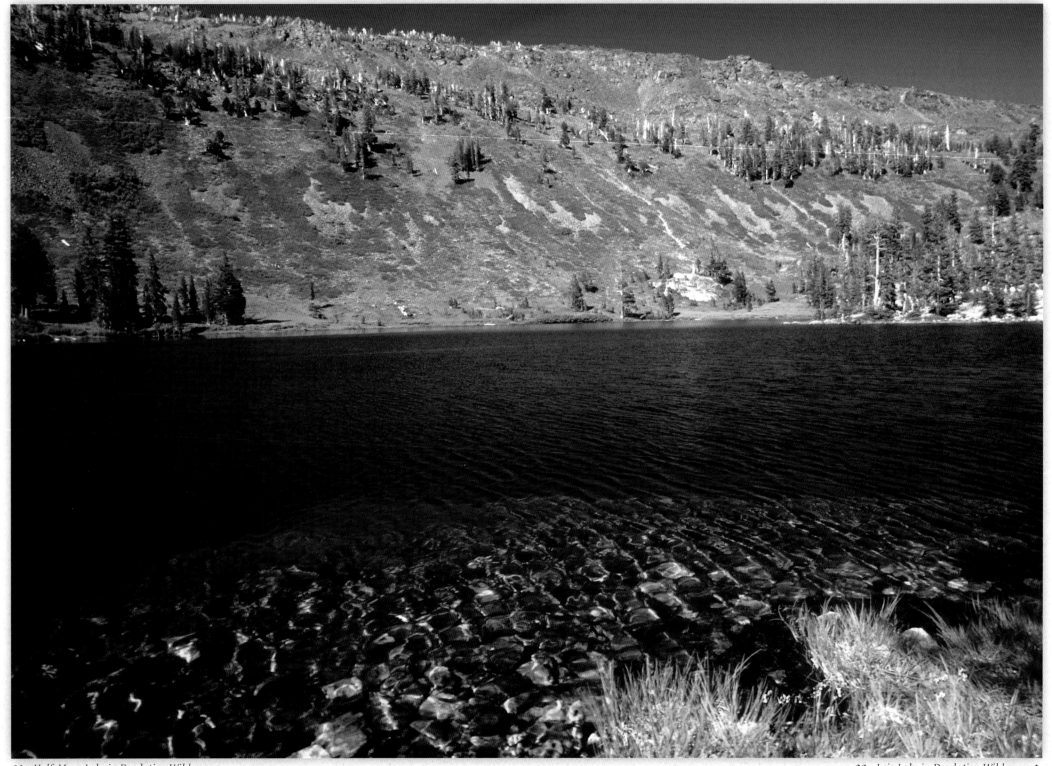

22. *Half-Moon Lake in Desolation Wilderness*

23. *Lois Lake in Desolation Wilderness* ▶

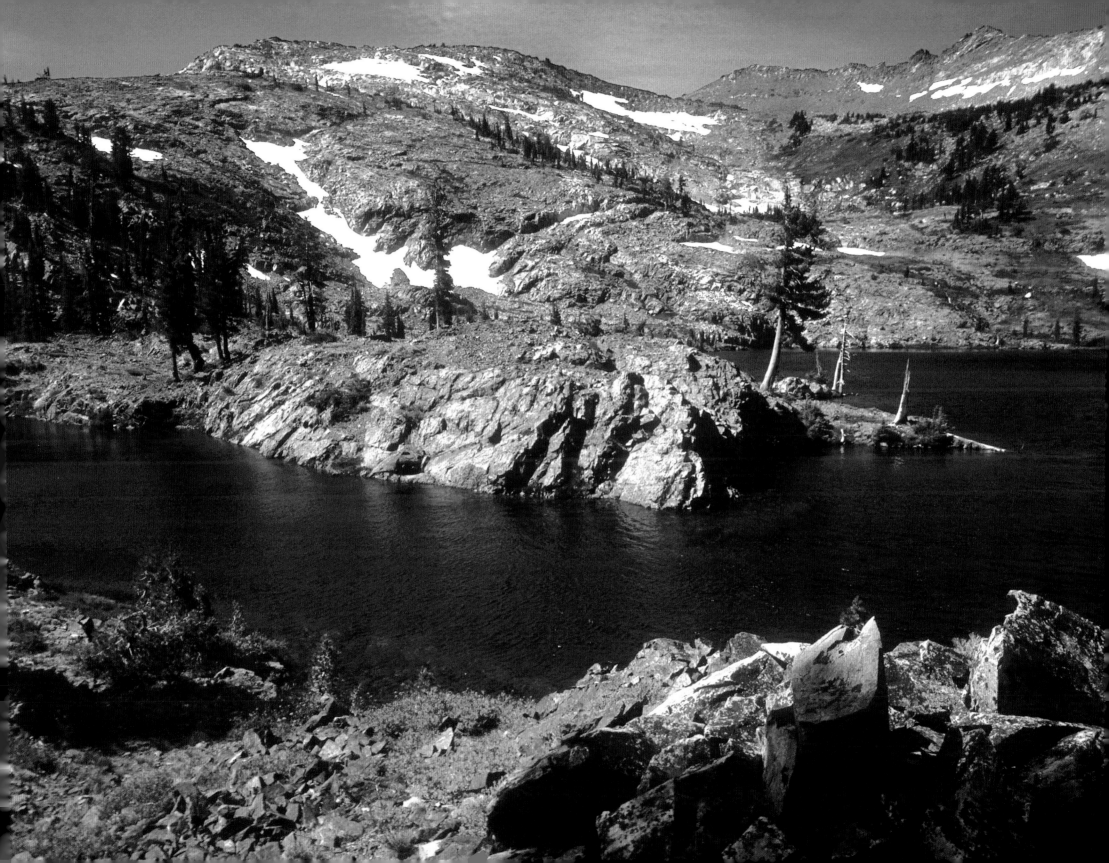

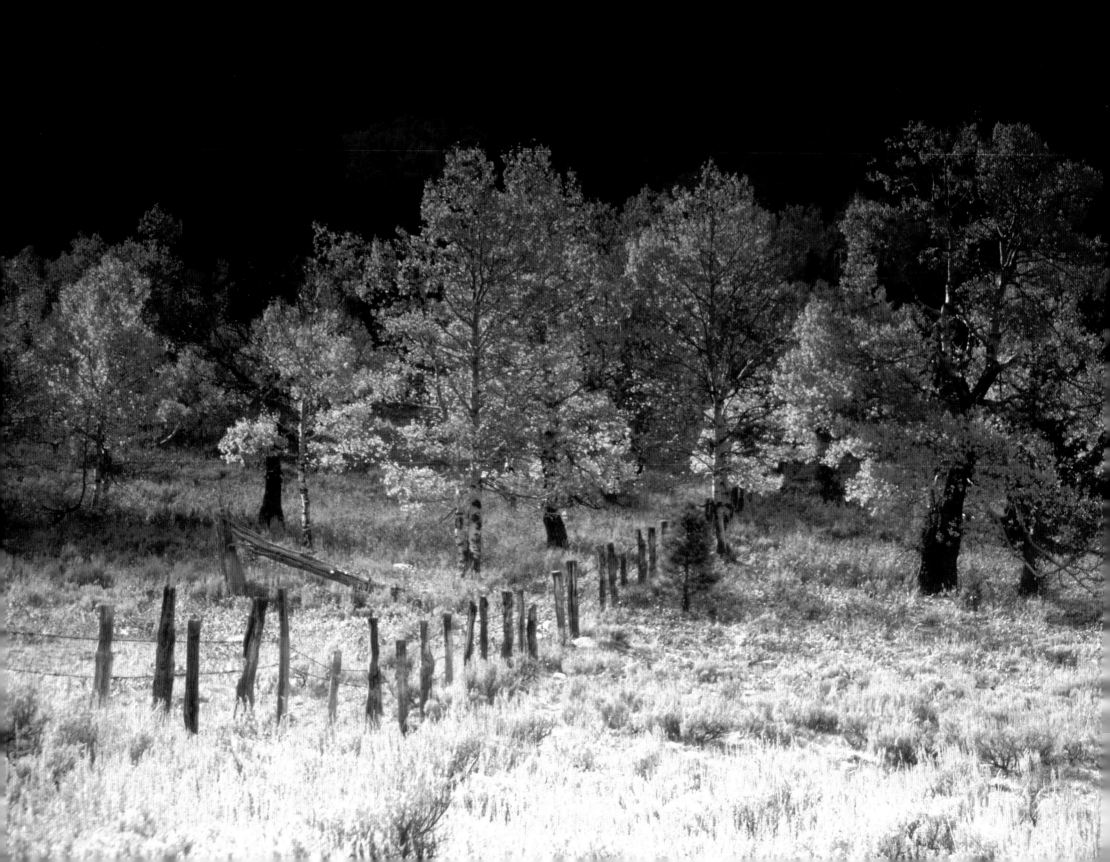

The Seasons of Tahoe

As journeys unfold, time elapses. If you spend enough time in one place you begin to get a sense of the natural rhythm and organized progressions of the time there. Each season brings to Tahoe a new face, a changing of the mood. Each has its own beauty, each its own personality. One thing remains constant in all these changes; that is the spell that Tahoe weaves around those who seek the beauty of its different seasons. A folk song entitled "The Circle Game" says, "The seasons they go round and round like a carousel in time." With each spin, Tahoe gives to visitors another look and dimension to its nature. I have been blessed to experience the better part of forty different spins of this carousel of life at Tahoe.

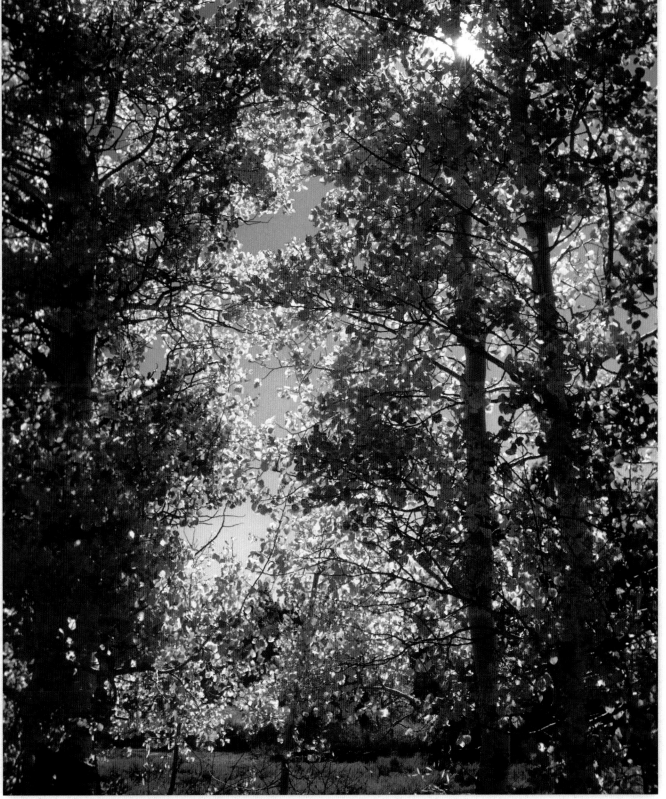

◄ **24.** *Fall color in Hope Valley*

25. *Fall color at Spooner Lake*

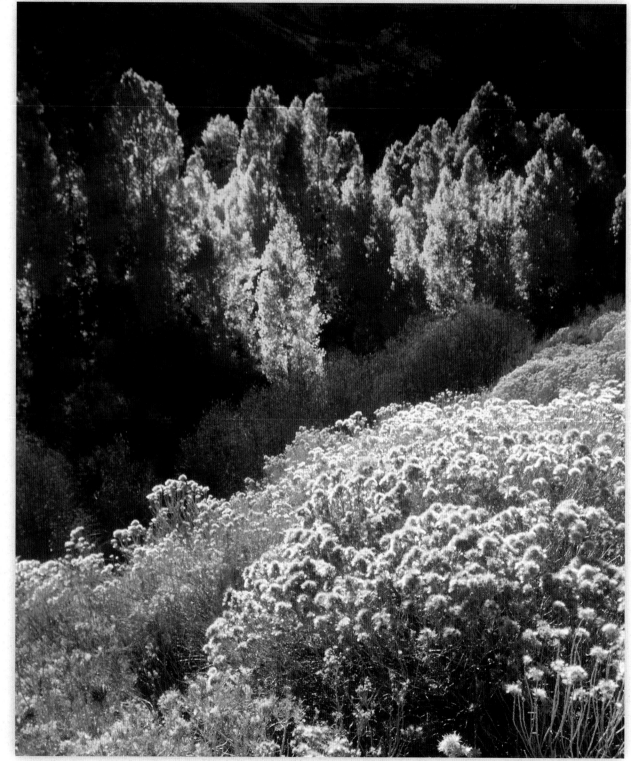

26. *Fall color in Hope Valley*

27. *Fall color in Hope Valley* ▶

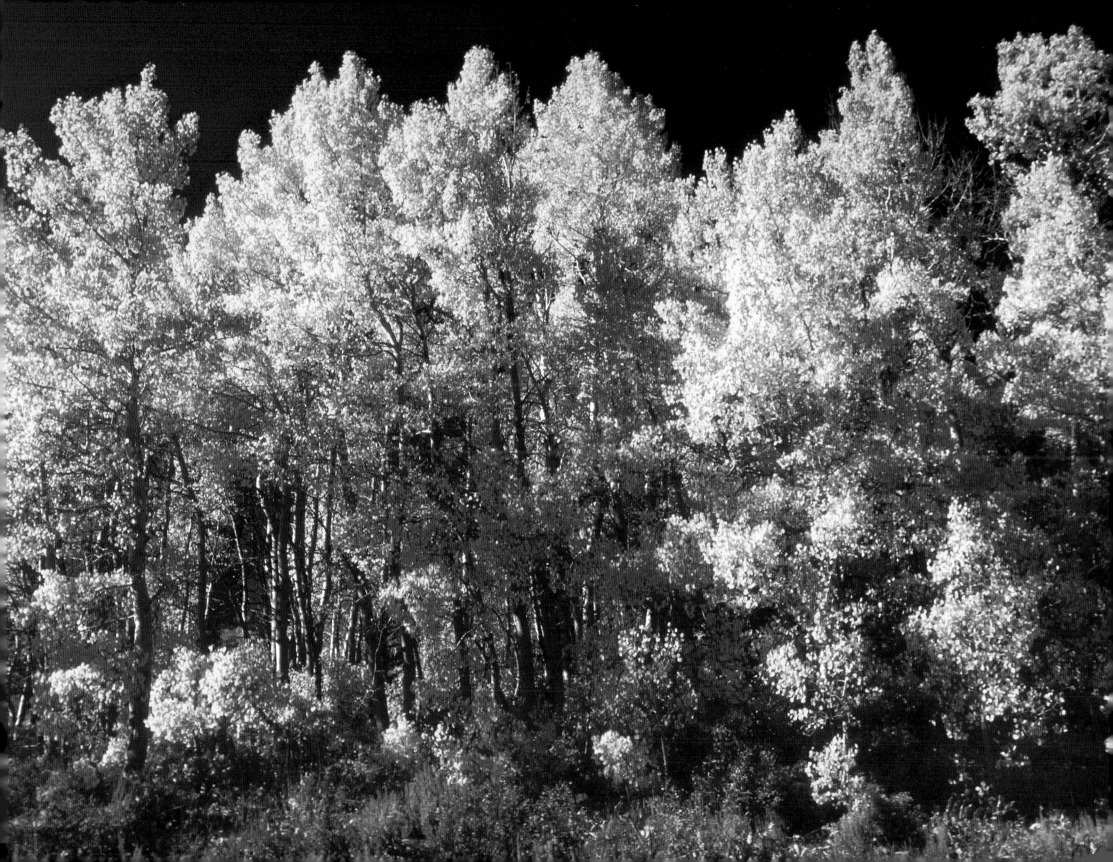

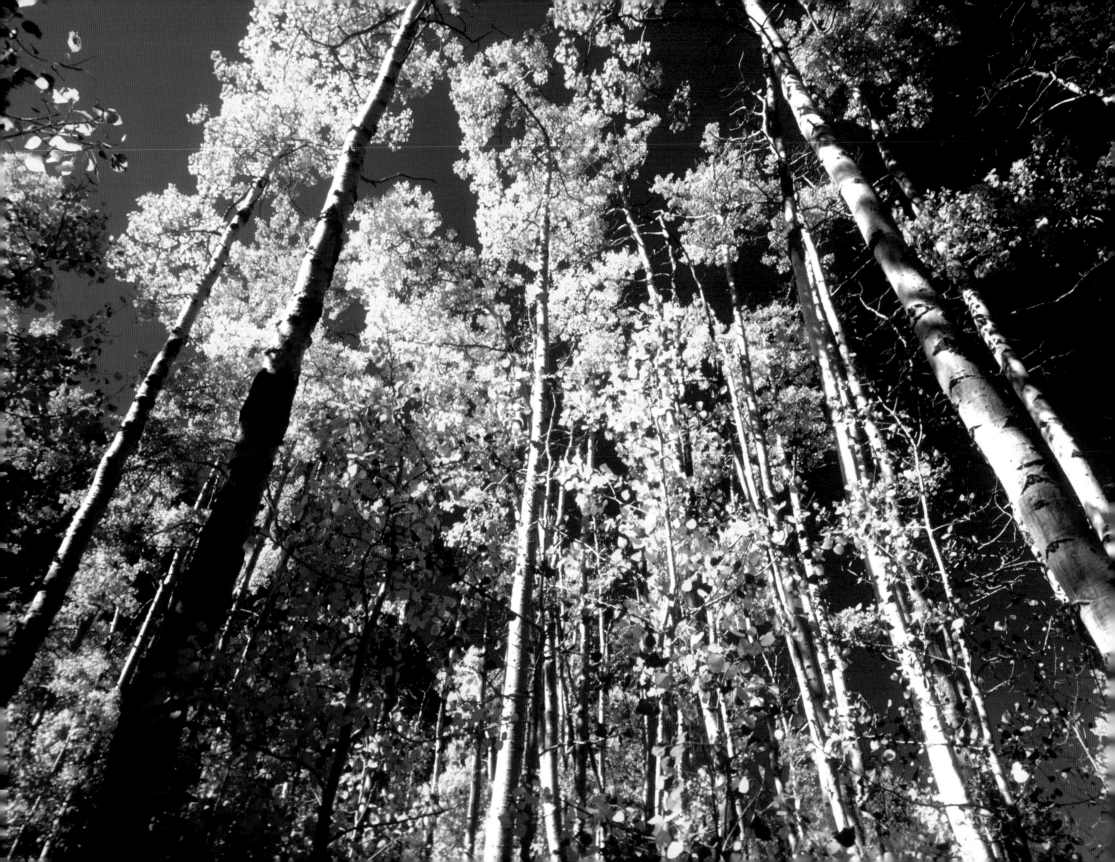

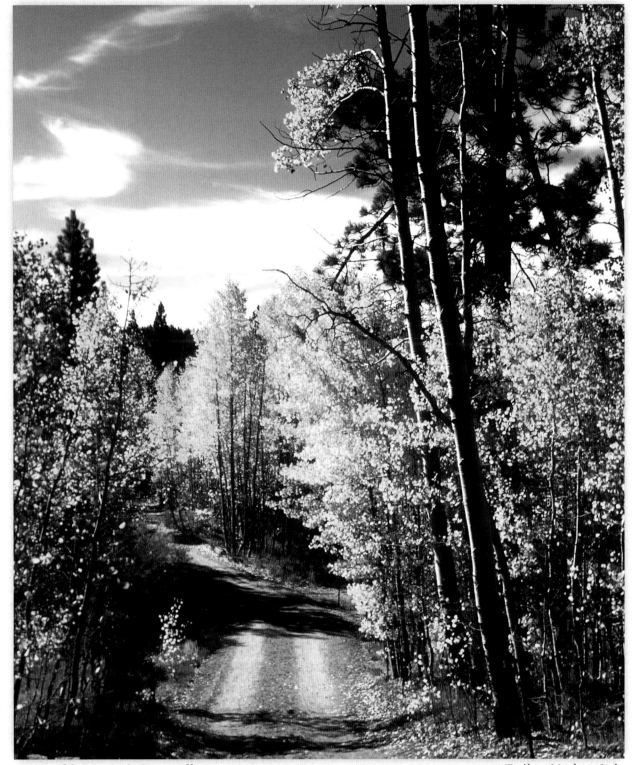

◄ **28.** *Golden Aspen in Hope Valley*

29. *Trail to Marlette Lake*

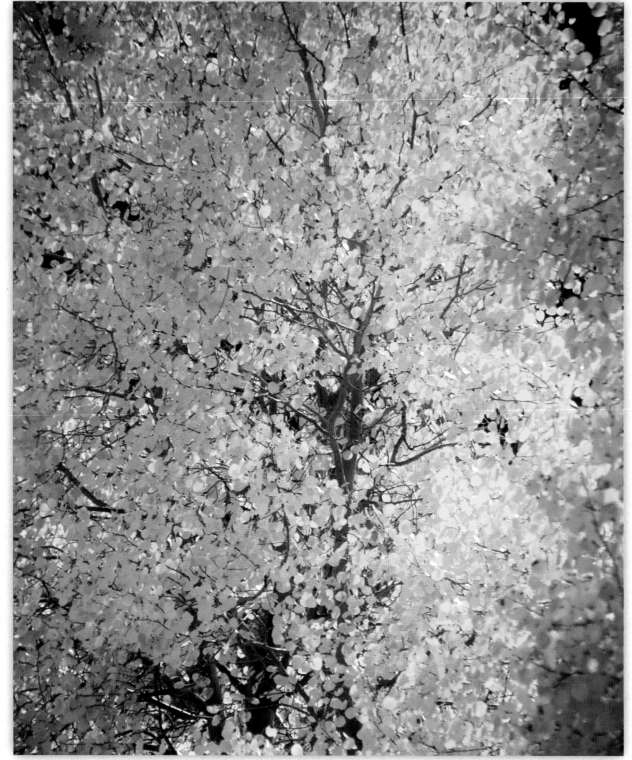

30. *Fall color along Old Clear Creek Road*

31. *Marlette Lake* ▶

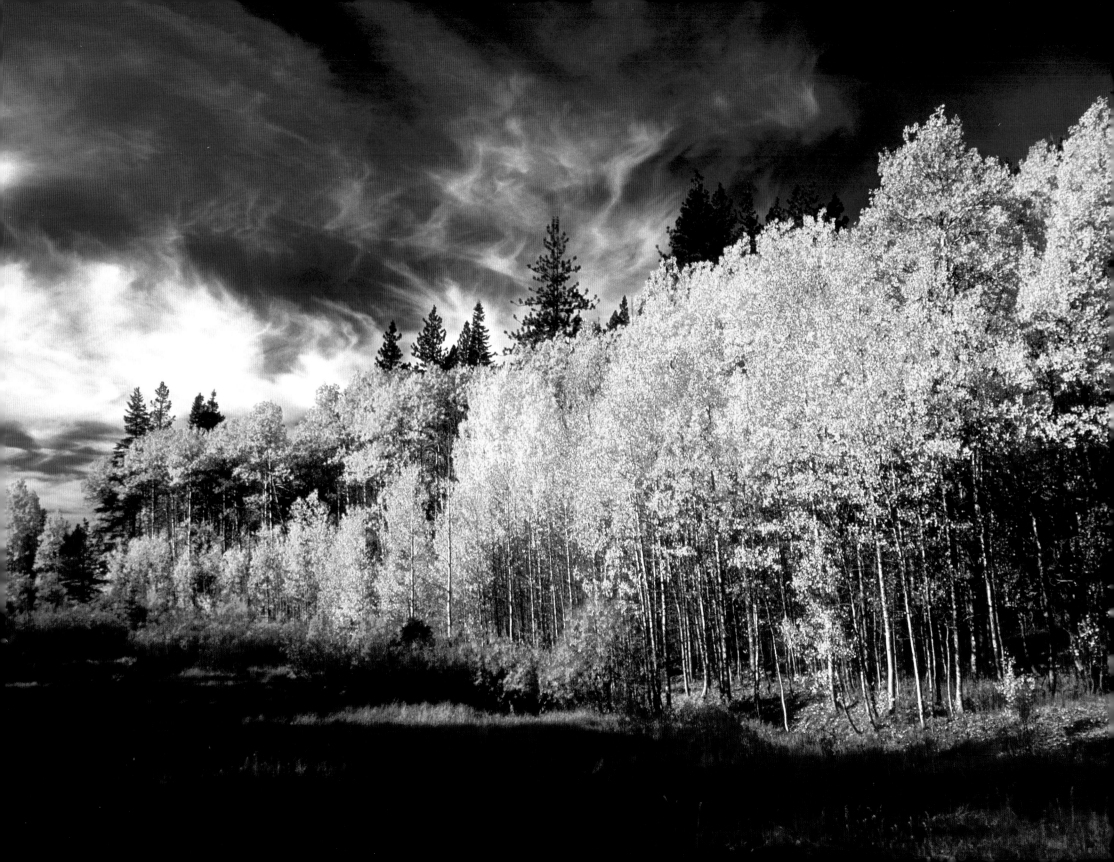

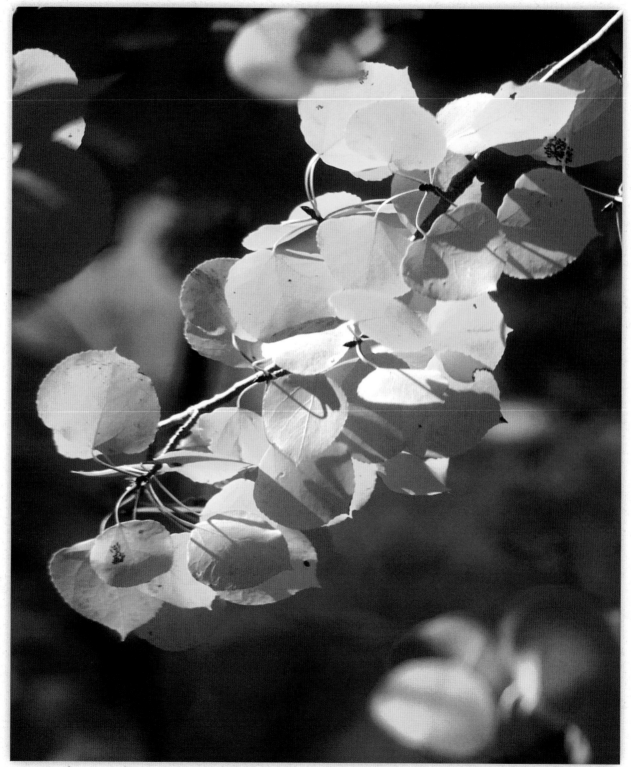

32. *Aspen leaves at the Aspen Grove in Incline Village* **33.** *Fall color at Hidden Beach Creek* ▶

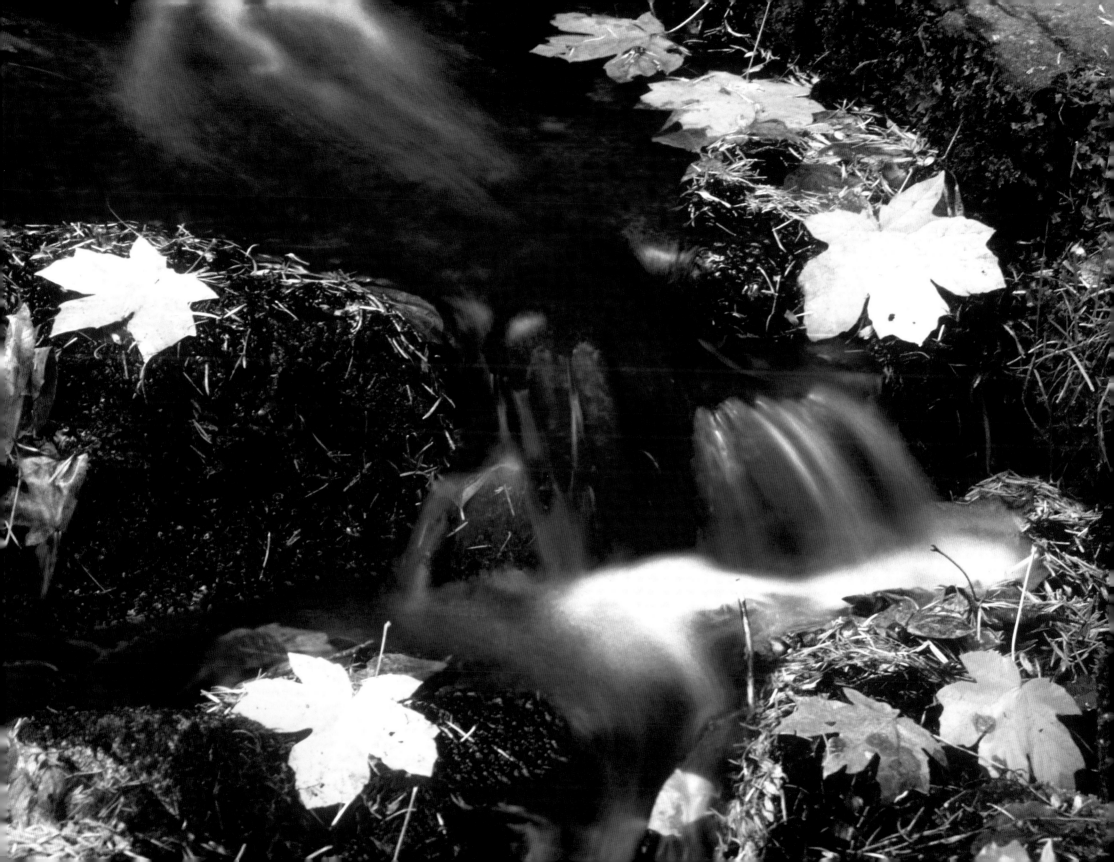

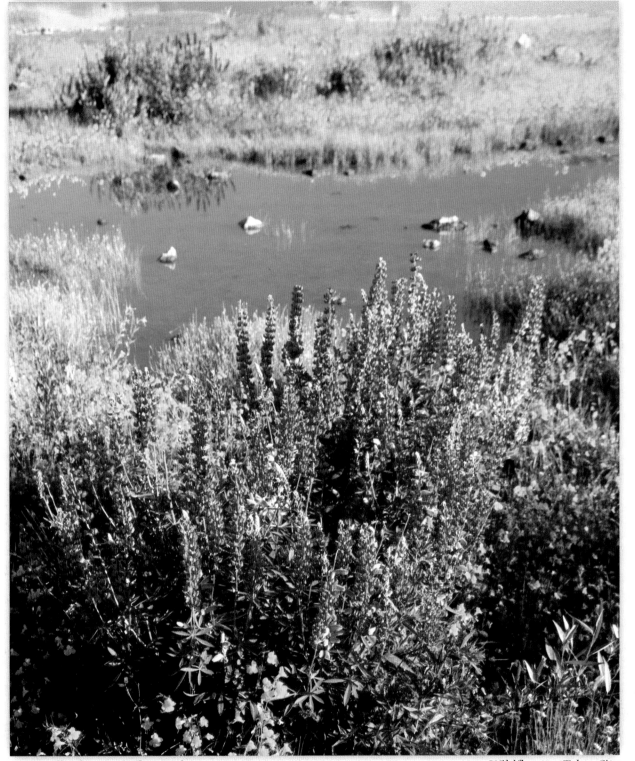

◄ 34. *Fall color at Marlette Lake*

35. *Wildflowers: Tahoe City*

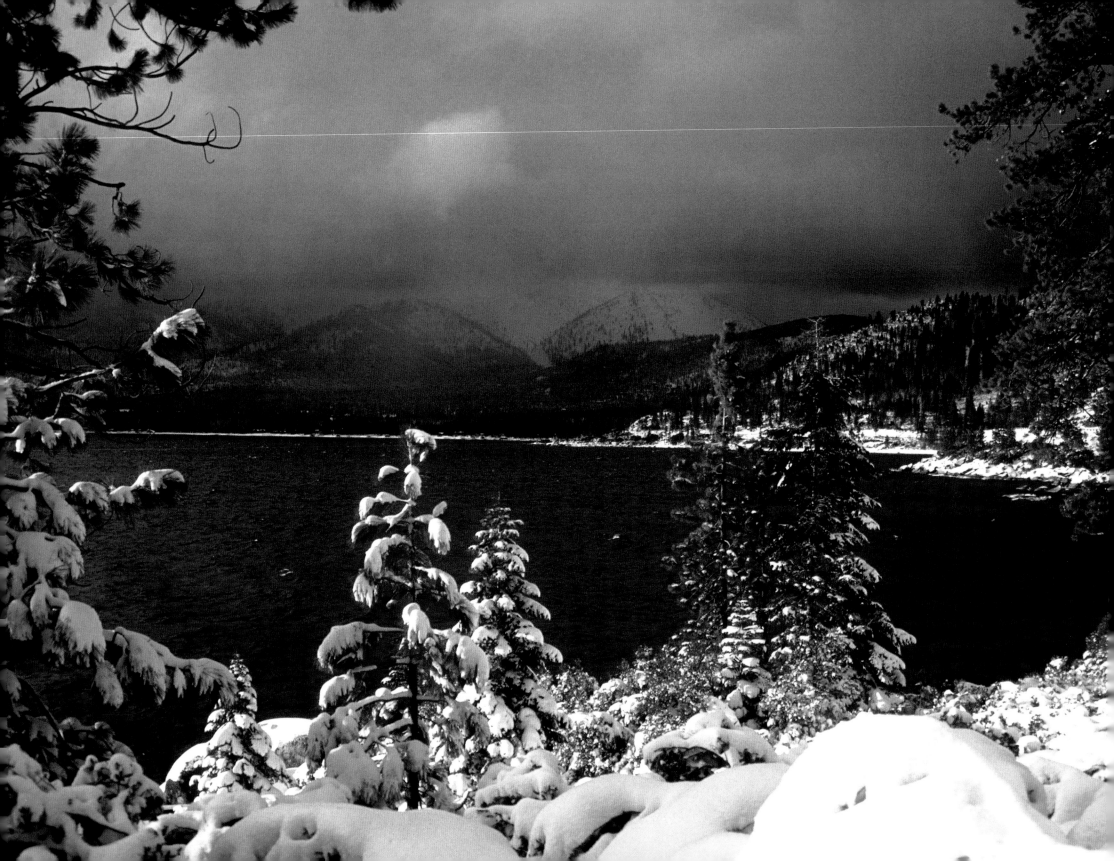

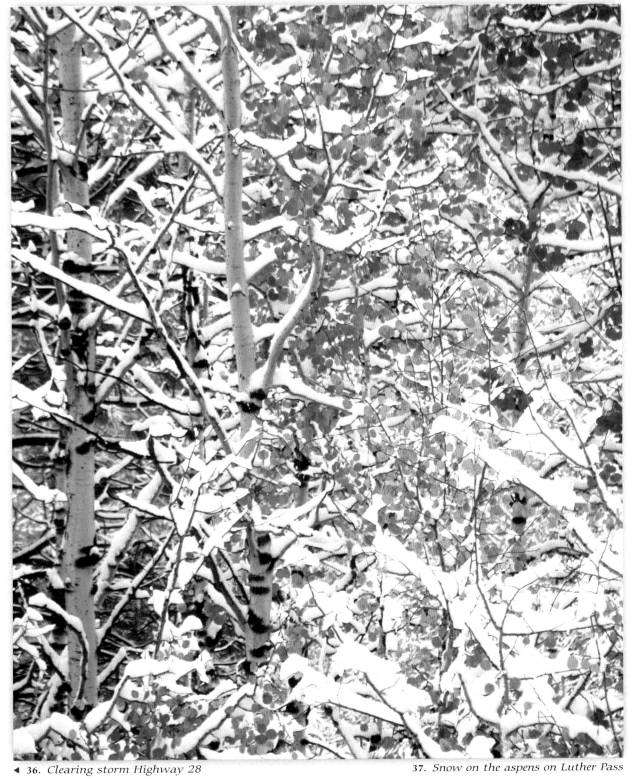

◄ 36. *Clearing storm Highway 28*

37. *Snow on the aspens on Luther Pass*

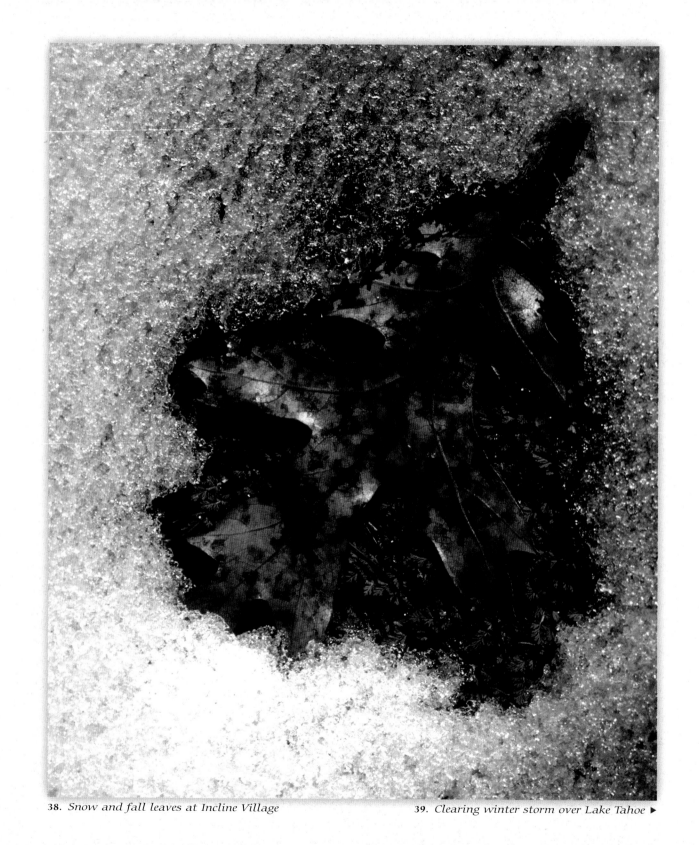

38. *Snow and fall leaves at Incline Village* 39. *Clearing winter storm over Lake Tahoe* ▶

42

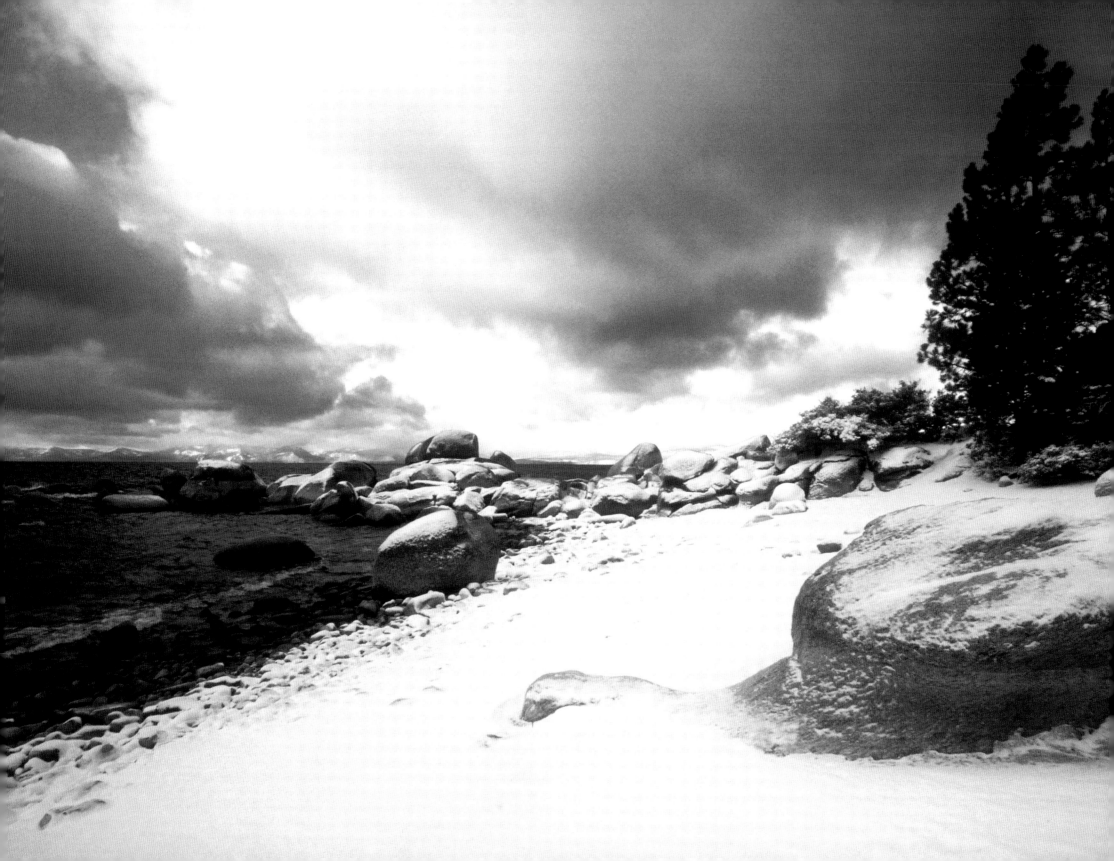

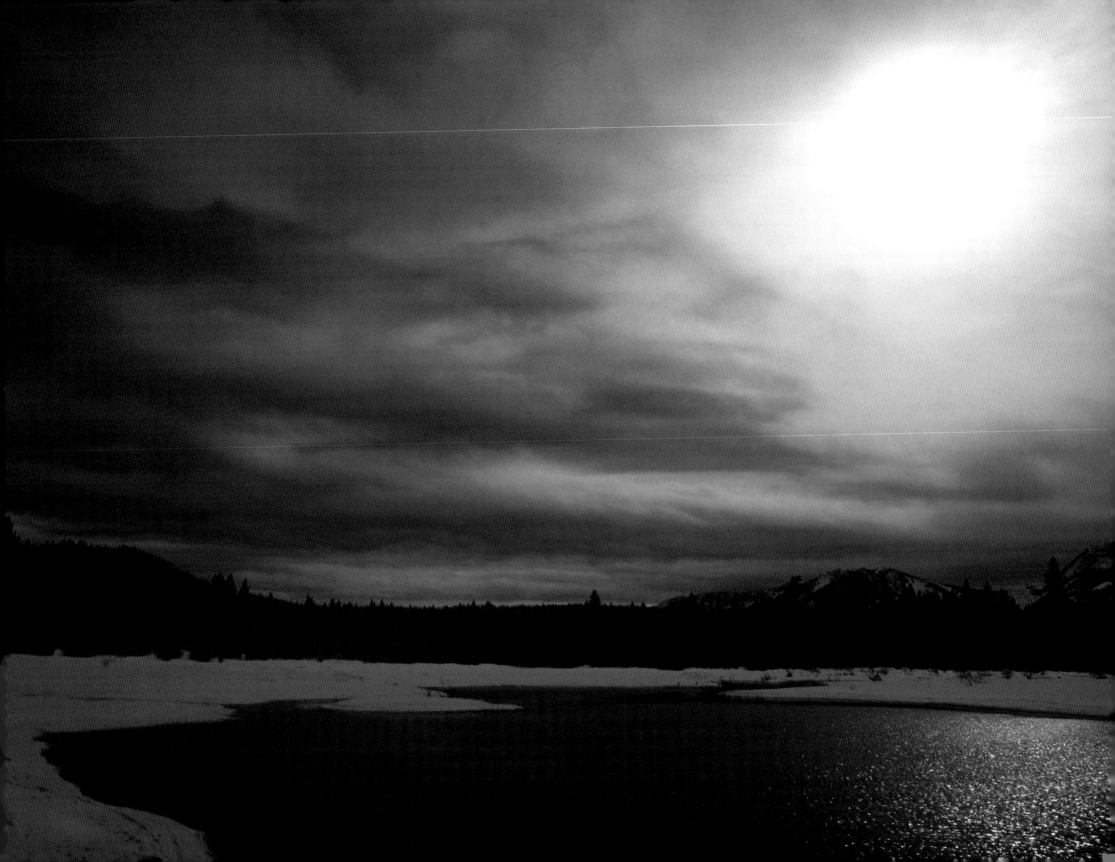

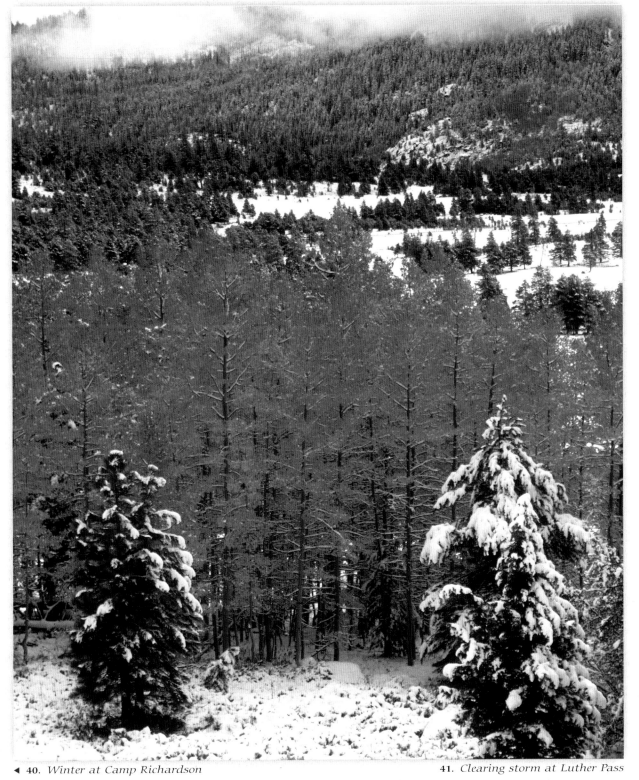

◄ **40.** *Winter at Camp Richardson*

41. *Clearing storm at Luther Pass*

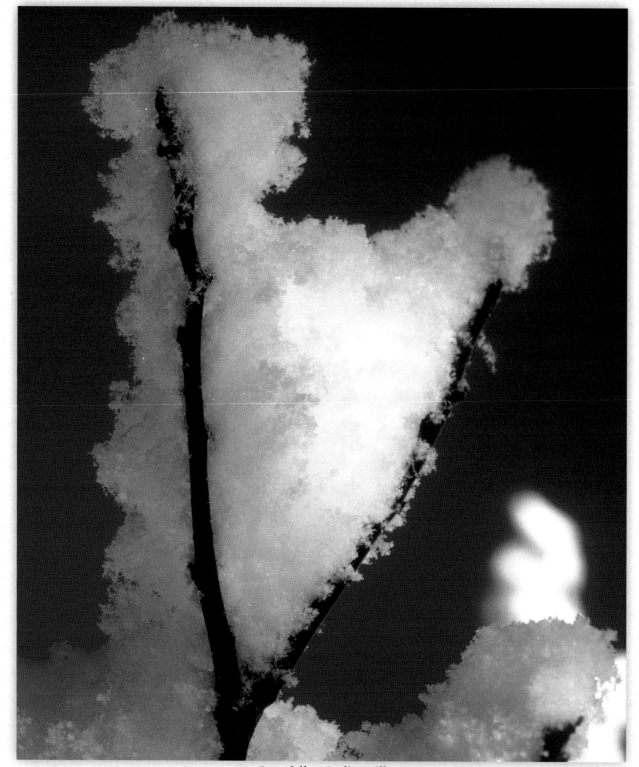

42. *Snowfall at Incline Village*

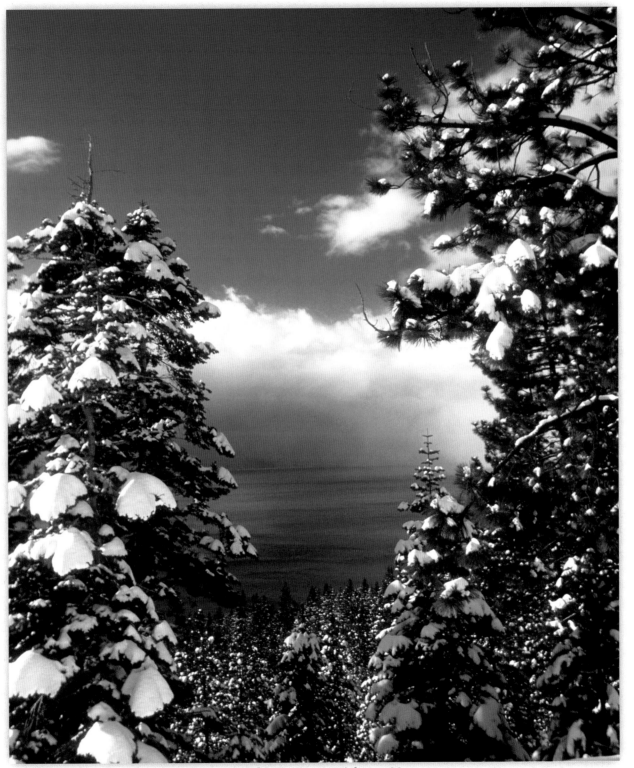

43. *Clearing storm Highway 28*

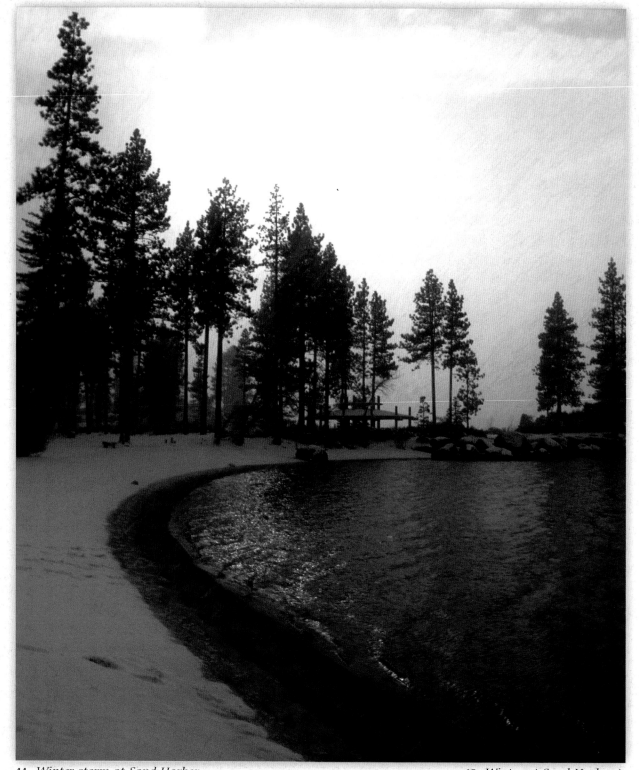

44. *Winter storm at Sand Harbor* **45.** *Winter at Sand Harbor* ▶

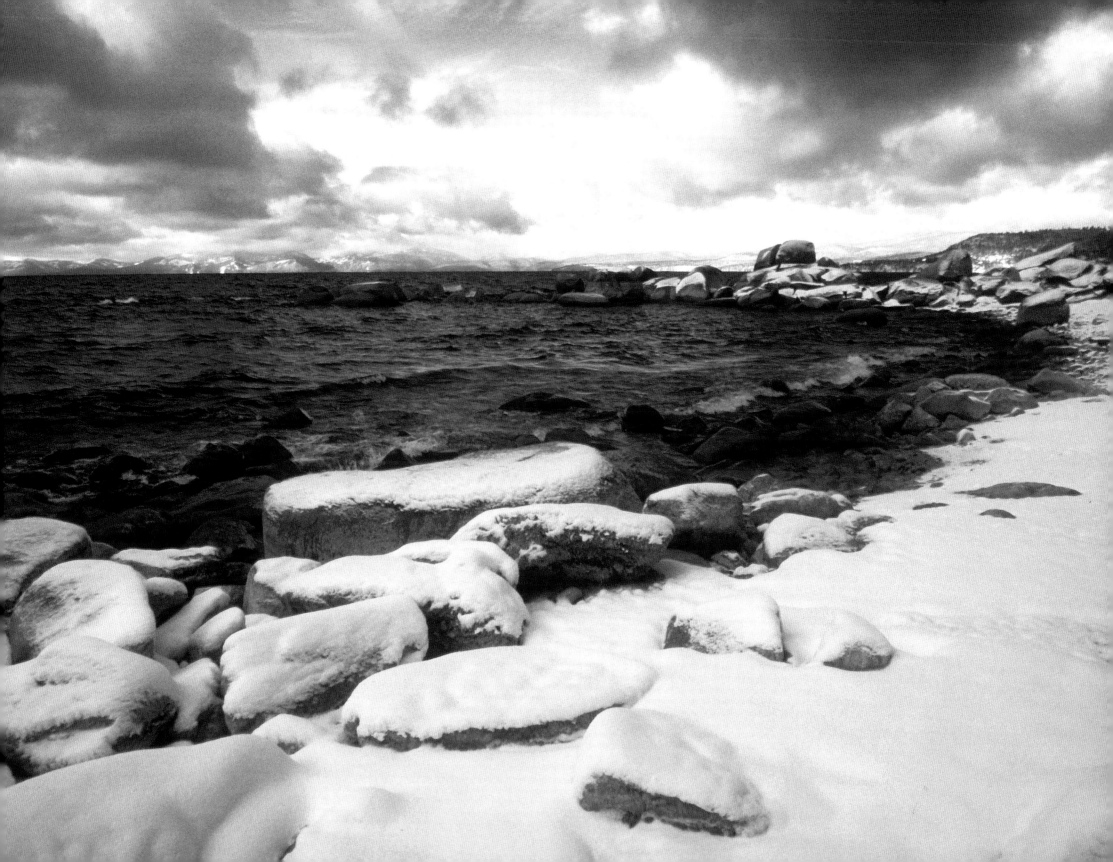

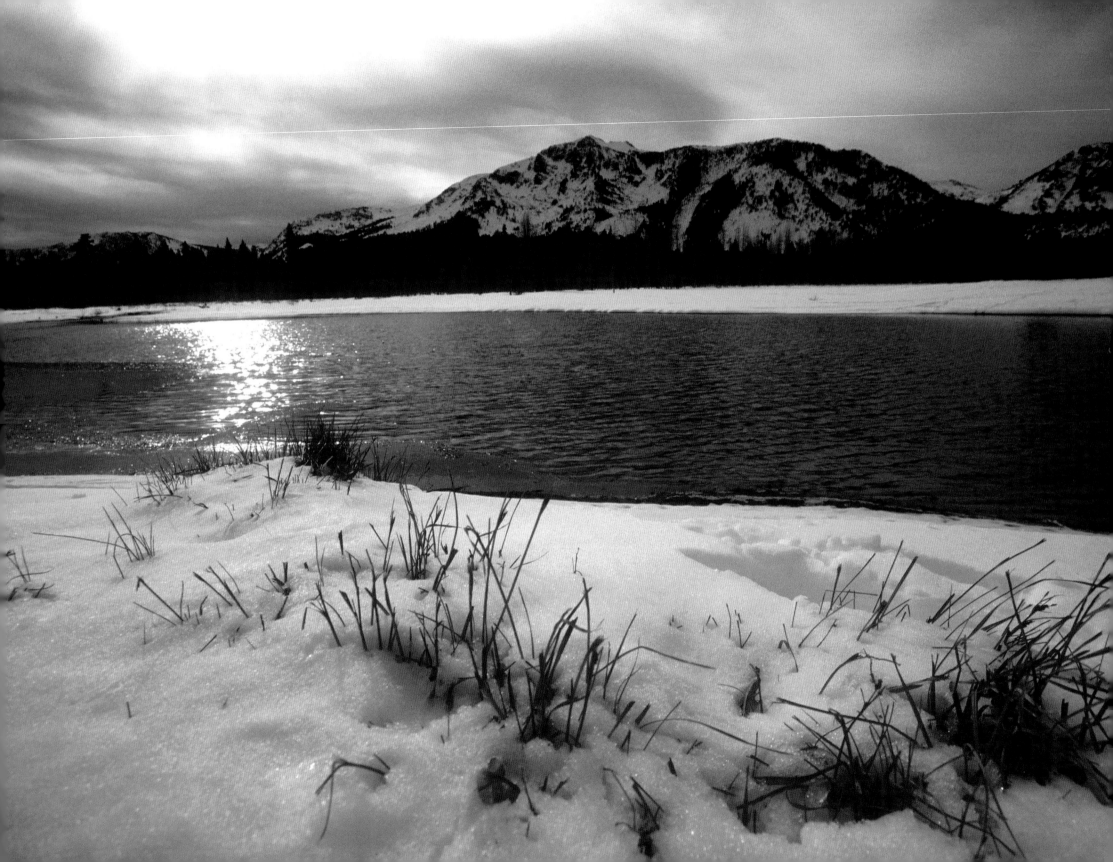

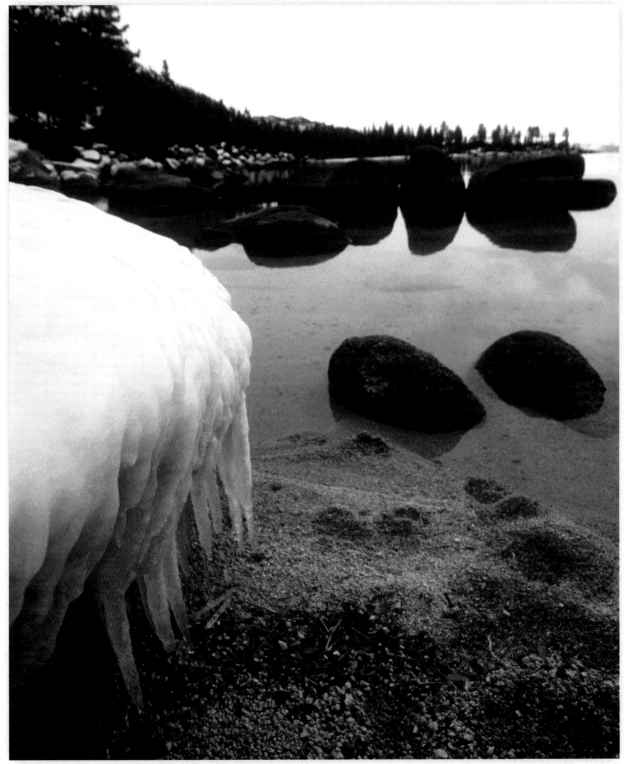

◄ 46. *Visitors' Center at South Shore*

47. *Ice crystals at Hidden Beach*

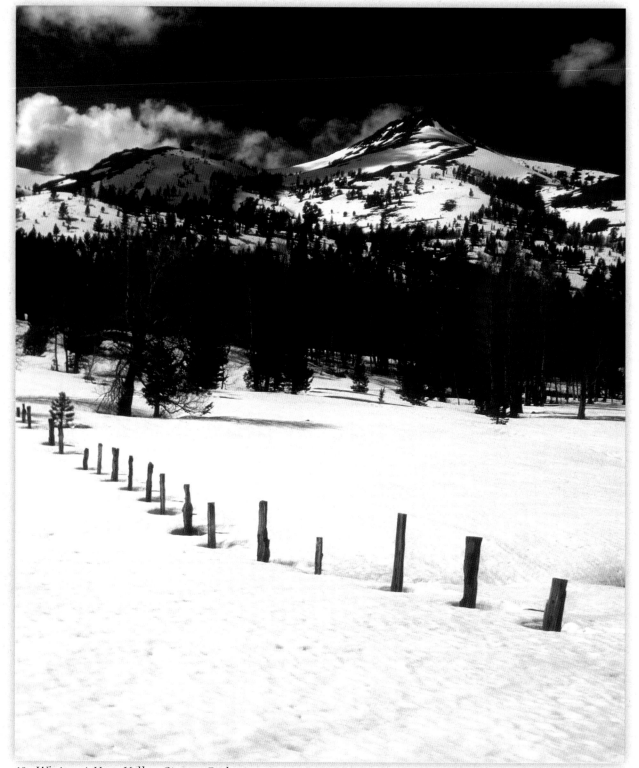

48. *Winter at Hope Valley, Stevens Peak*

49. *Winter scene at Hope Valley* ▶

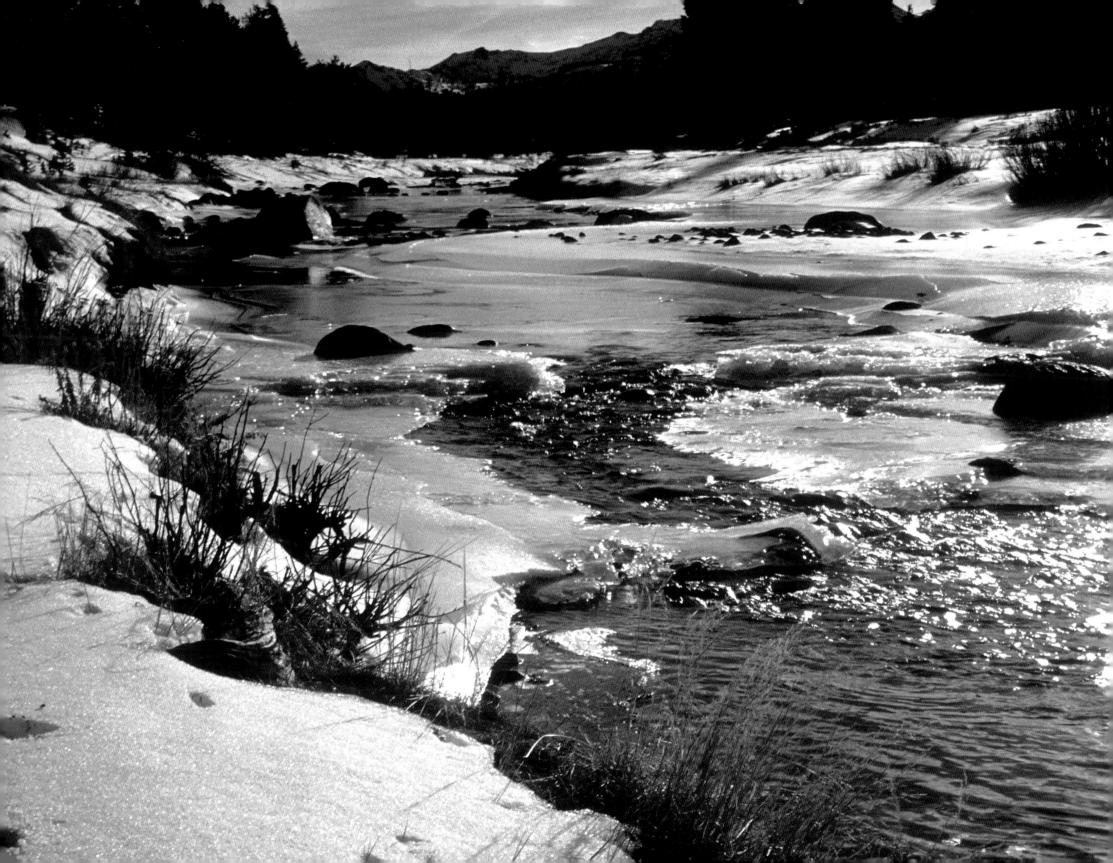

Moonsets and Sunsets

Of all the special times at Tahoe, the time of deepening shadows and diffused light have offered some of the most inspired and spiritual journeys. All along the east shore, the view to the west gives the visitor at twilight a glimpse of a master painter at work. On those special occasions when all the natural elements of clouds, atmosphere, and light diffusion come together, the show Tahoe puts on is far superior to any man-made production of lasers and fireworks. Colors ranging the whole spectrum are exhibited. The water shimmers and interacts with the colors and the world seems to stop silent and motionless so that Tahoe can present a flourish that rivals the ending of any Beethoven symphony. So simple, so unextraordinary, yet so profound and deeply moving. Another natural twenty-four hour journey is about to conclude with the deepening cobalt blue of the lake with the sky. To see Tahoe at sunset in its entire splendor is truly to be touched by the hands of the creator.

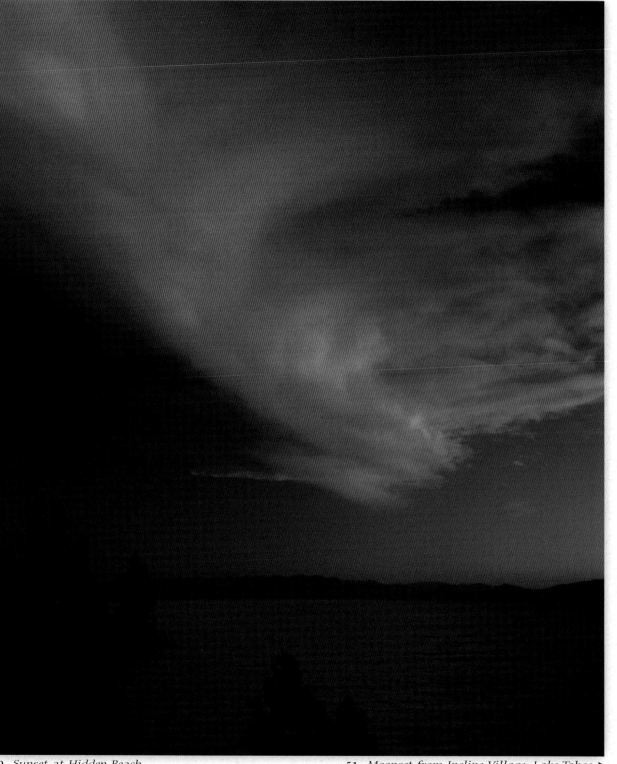

50. *Sunset at Hidden Beach*

51. *Moonset from Incline Village, Lake Tahoe* ▶

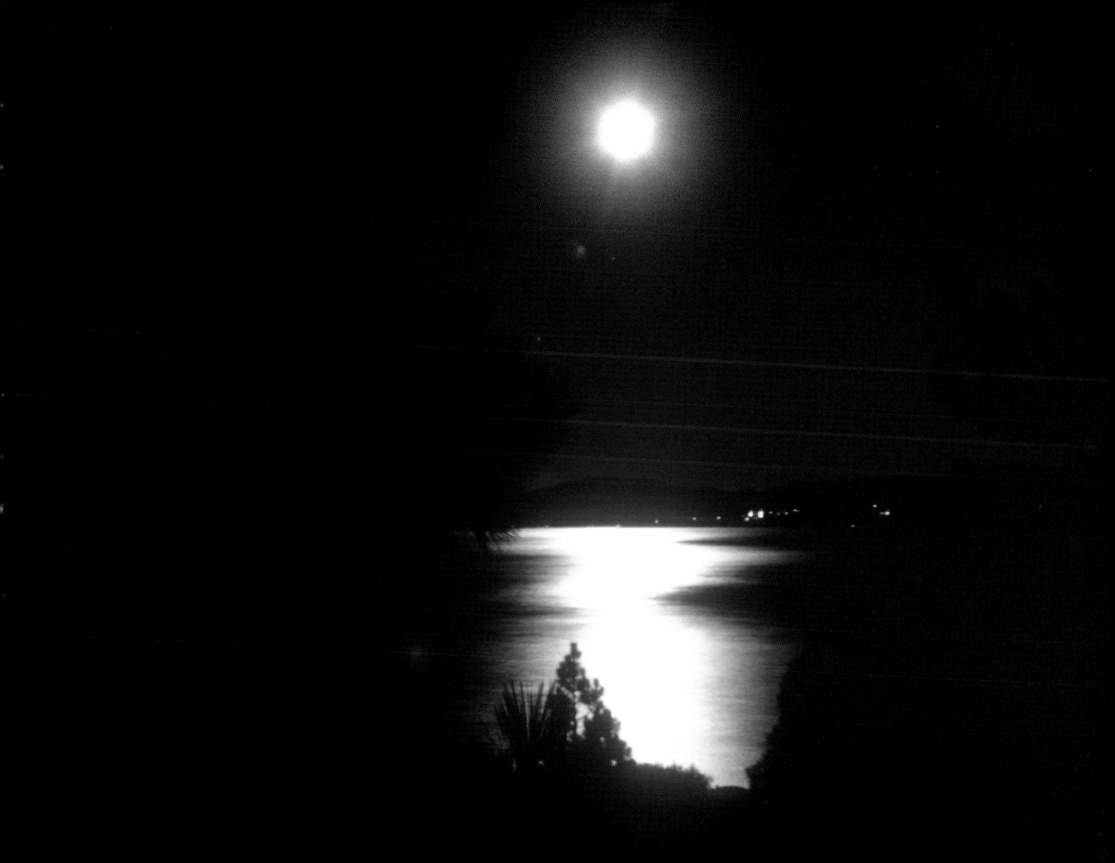

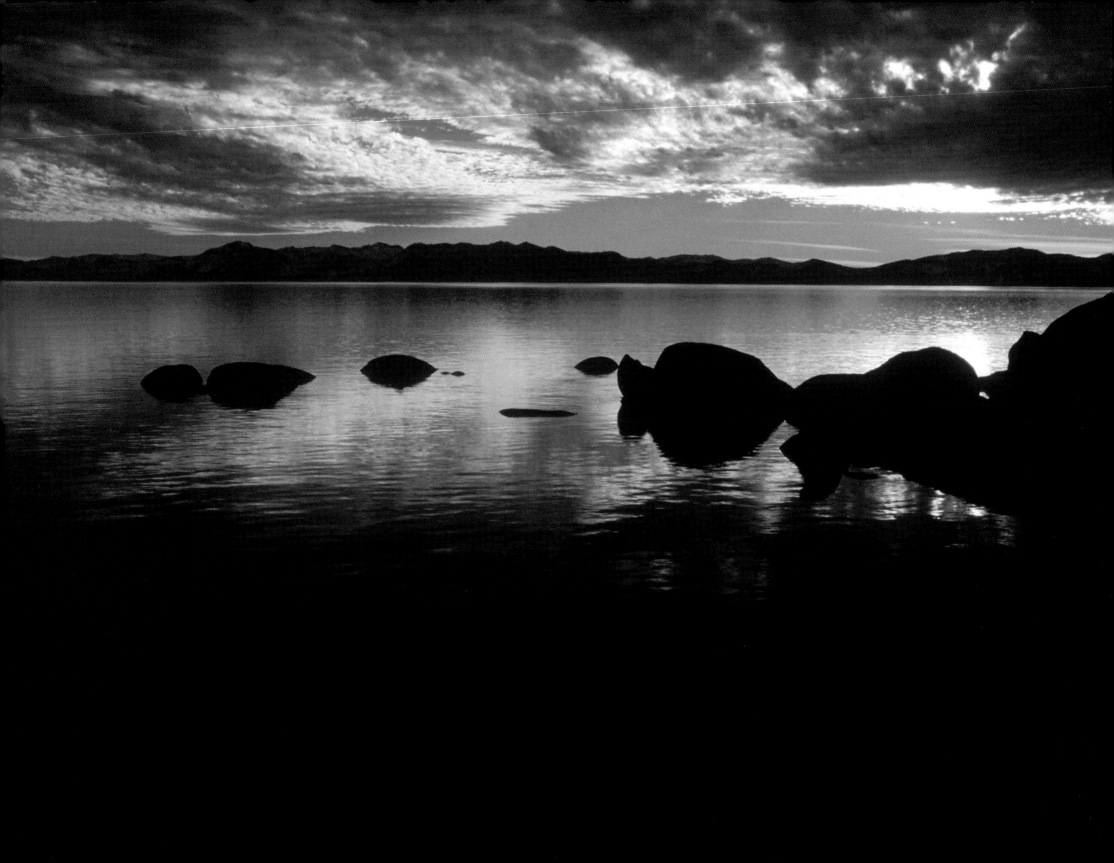

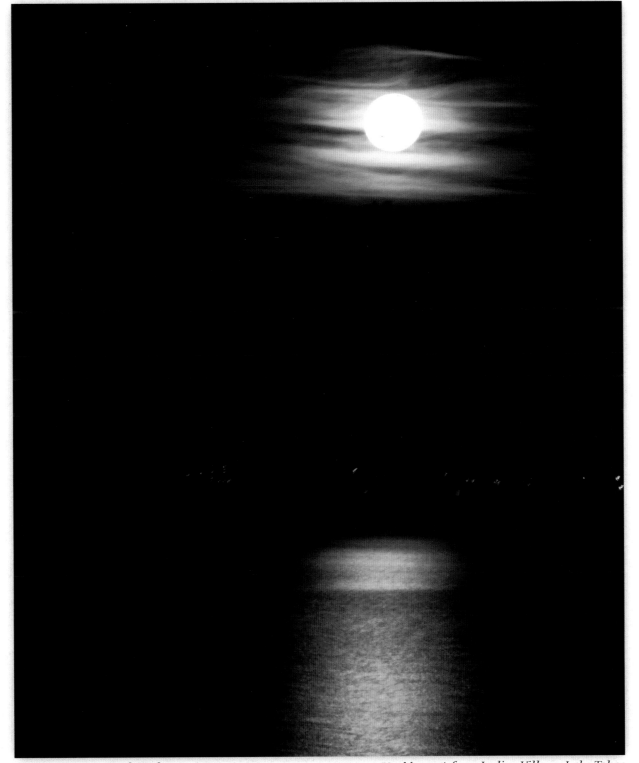

◀ **52.** *Sunset at Sand Harbor*　　　　　　**53.** *Moonset from Incline Village, Lake Tahoe*

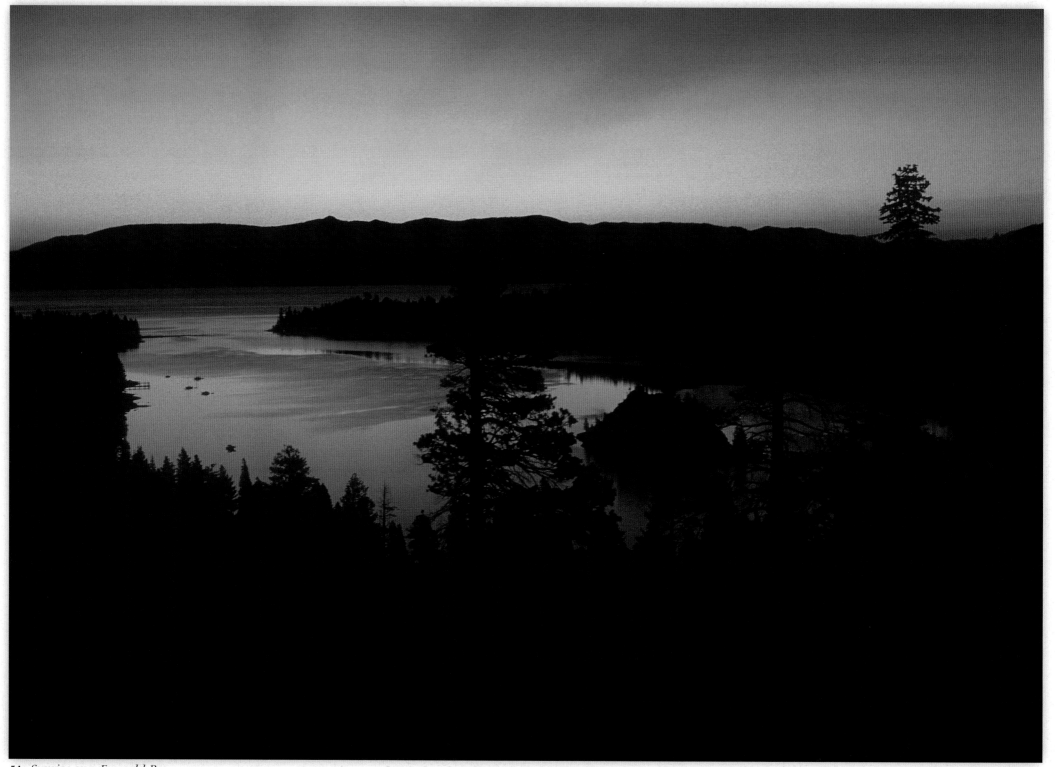

54. *Sunrise over Emerald Bay*

55. *Sunset at Cave Rock* ▶

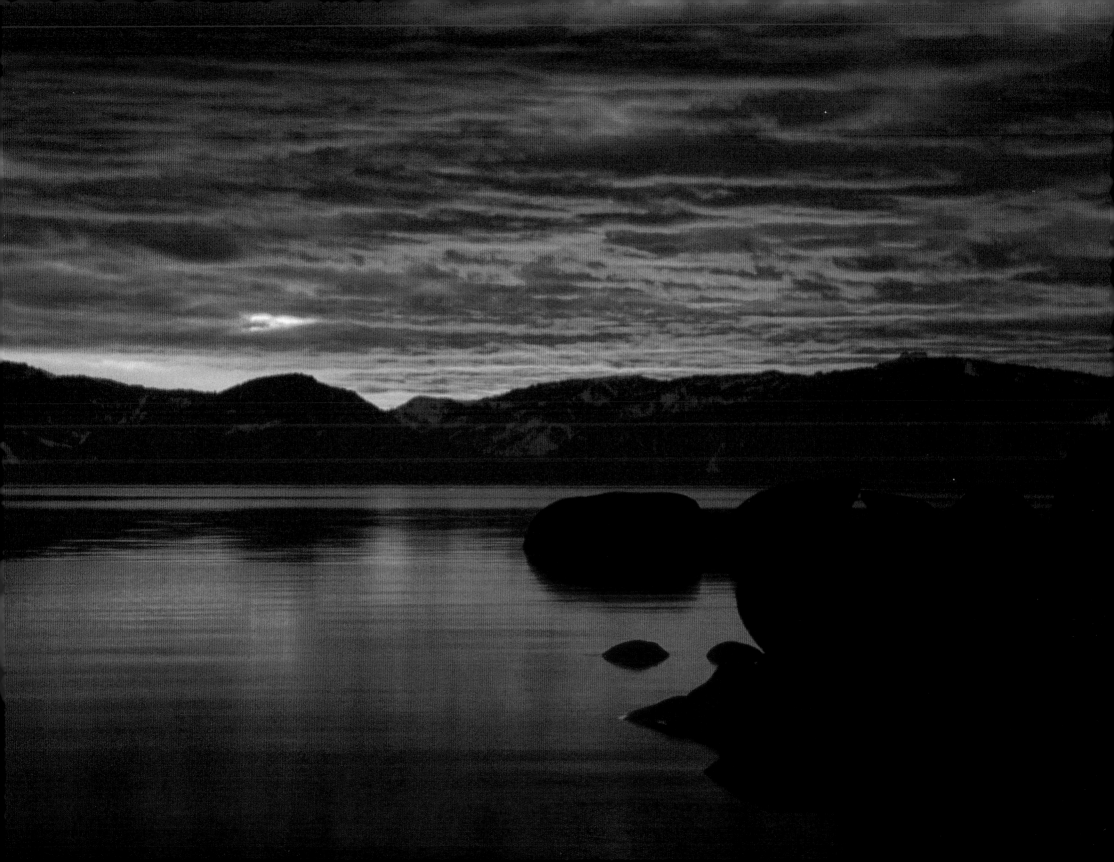

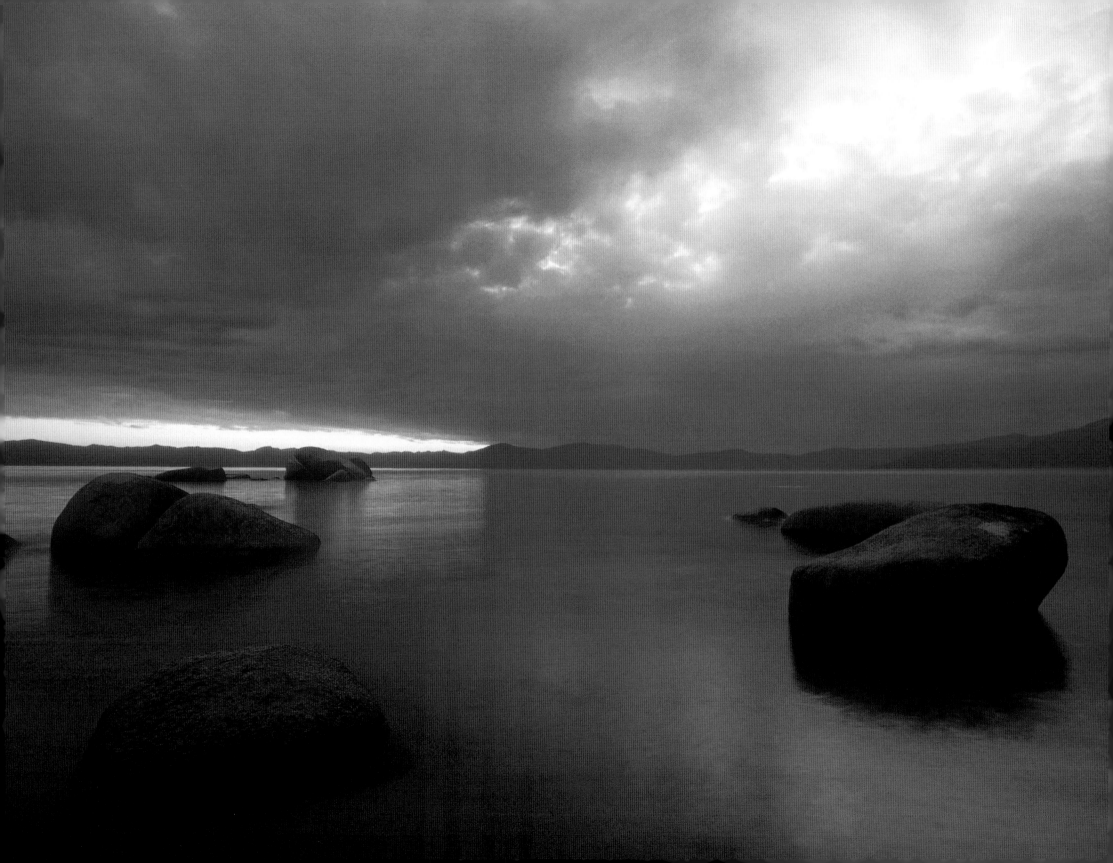

◄ **56**. *Sunset at Sand Harbor*

57. *Millennium Sunset from the backcountry cabin at Spooner Lake*

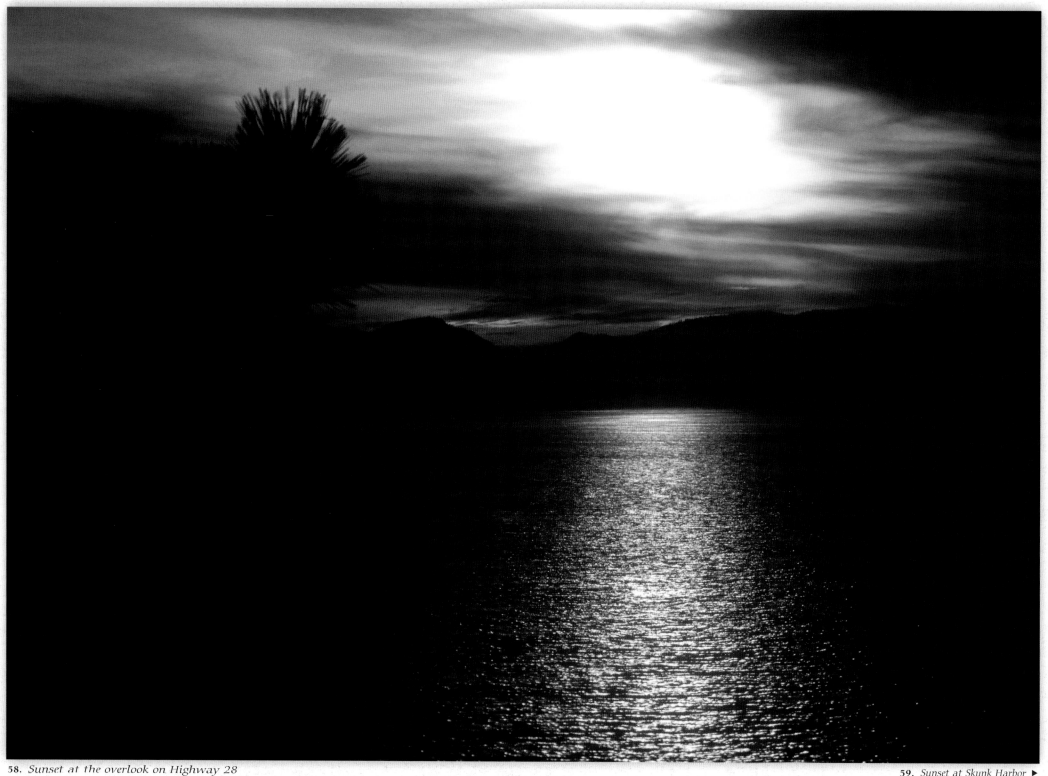

58. *Sunset at the overlook on Highway 28*

59. *Sunset at Skunk Harbor* ▶

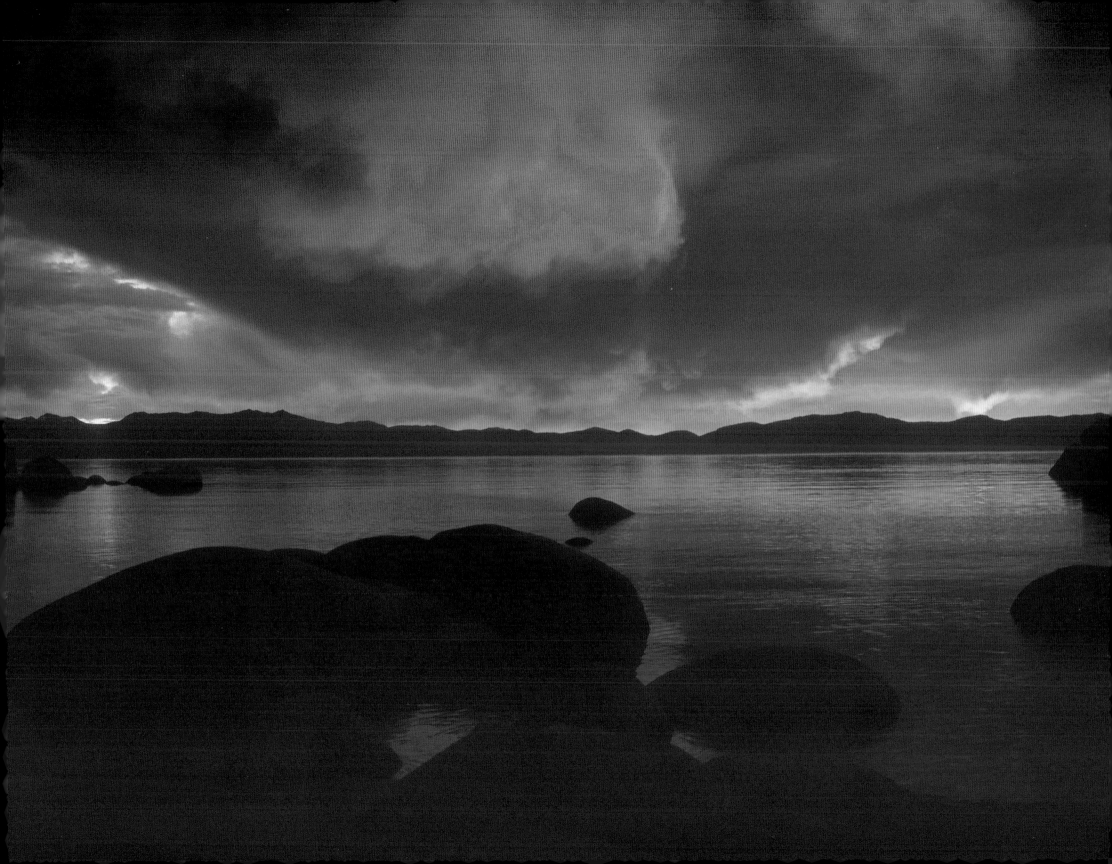

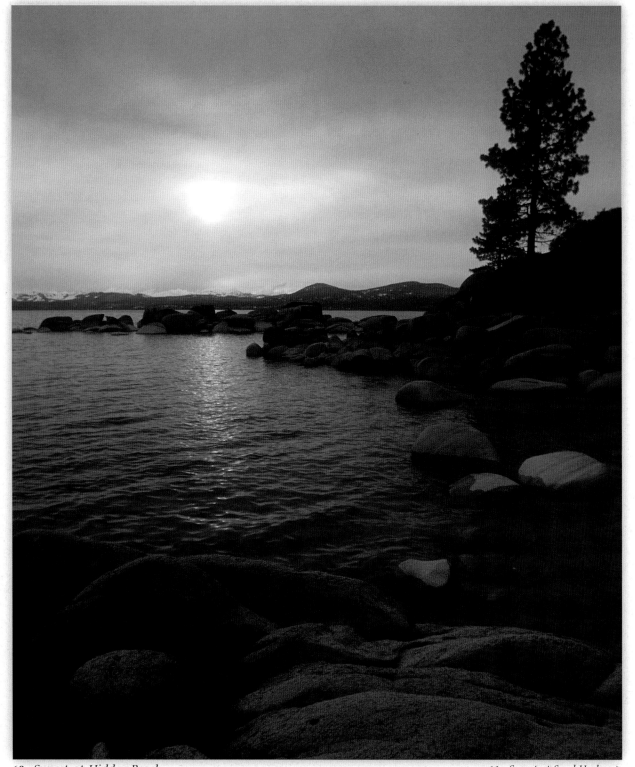

60. *Sunset at Hidden Beach*

61. *Sunset at Sand Harbor* ▶

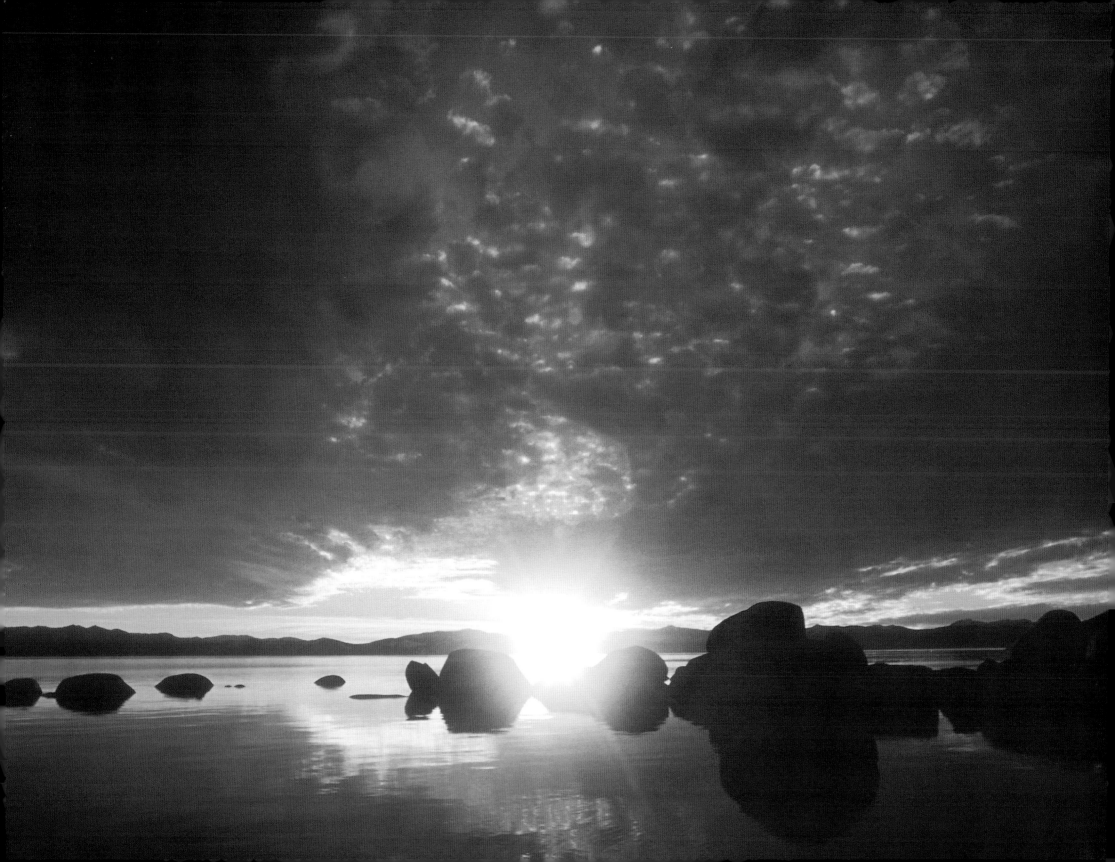

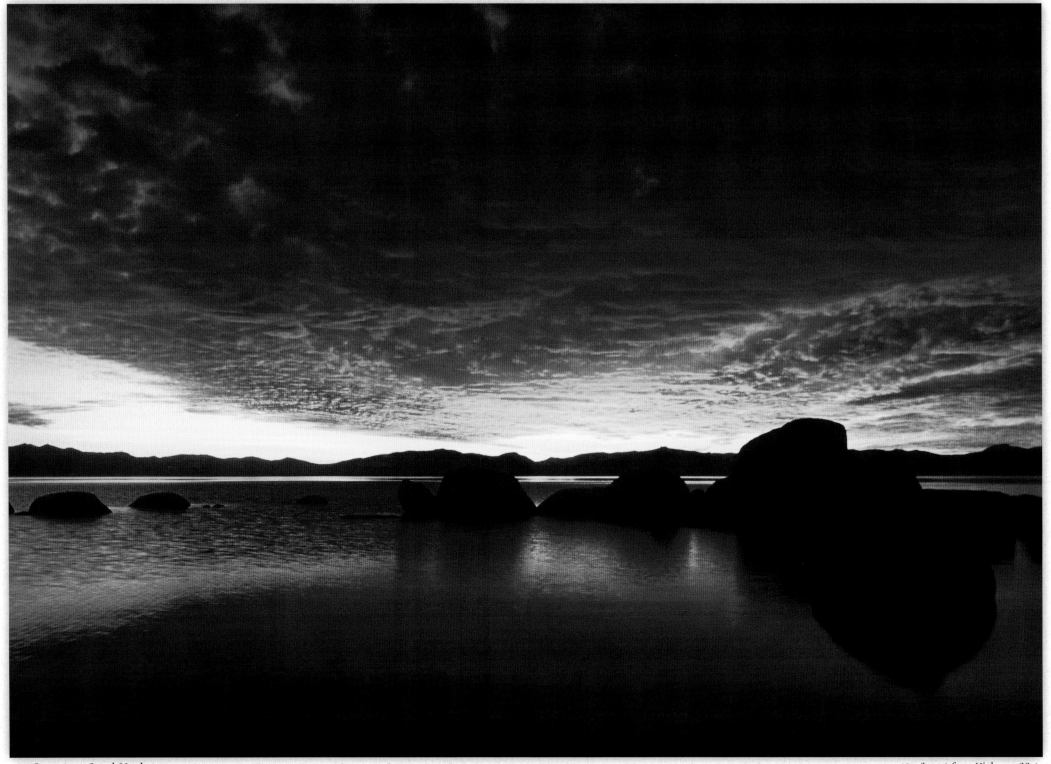

62. *Sunset at Sand Harbor*

63. *Sunset from Highway 28* ▶

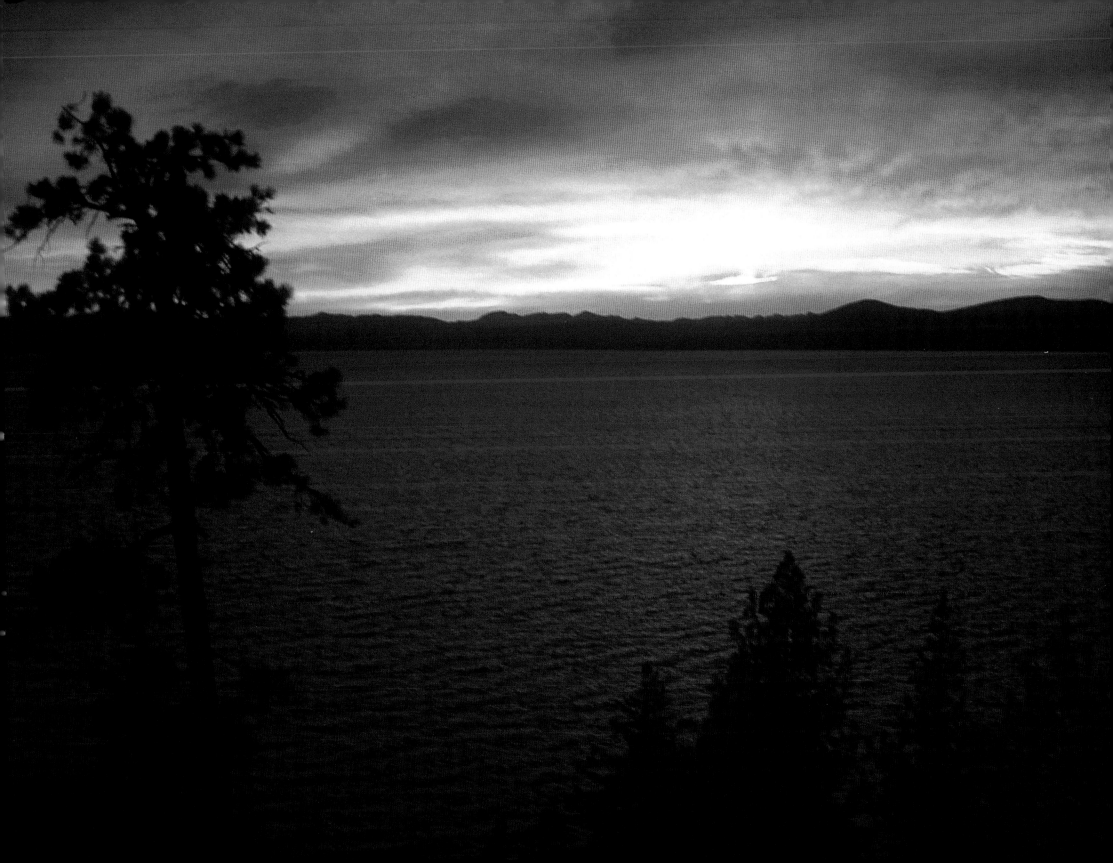

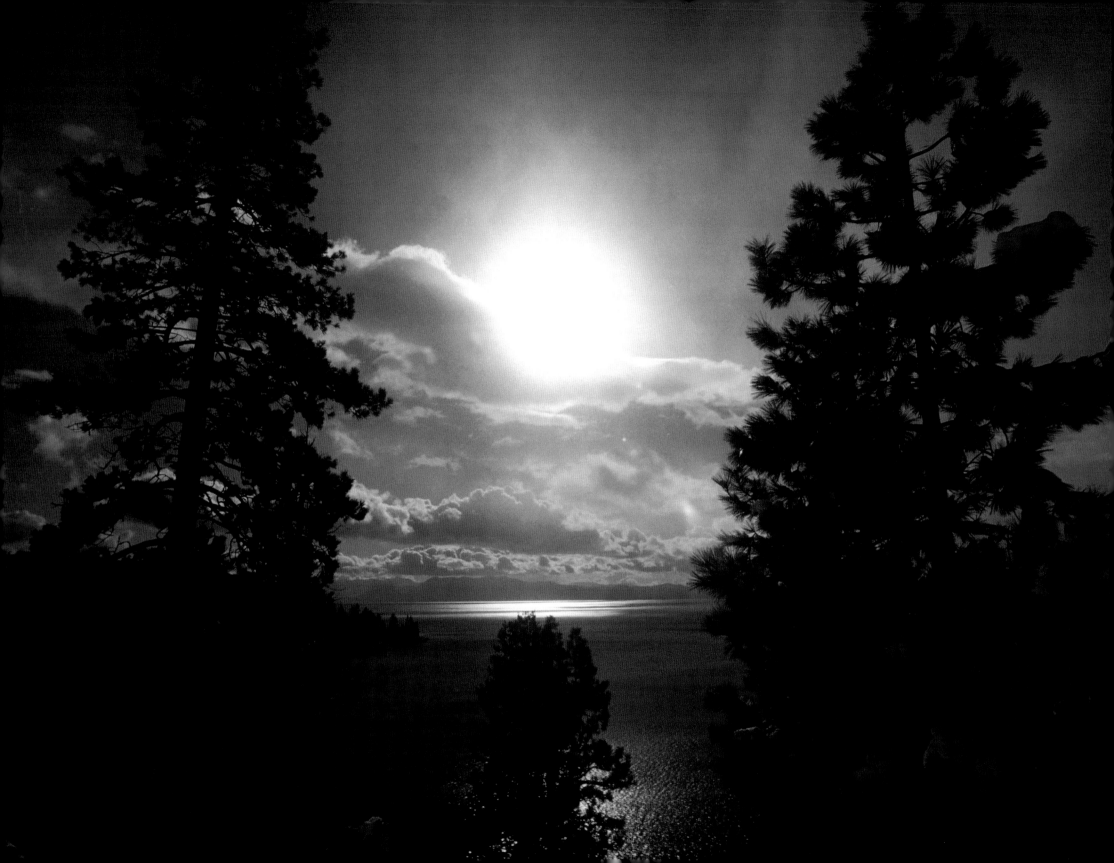

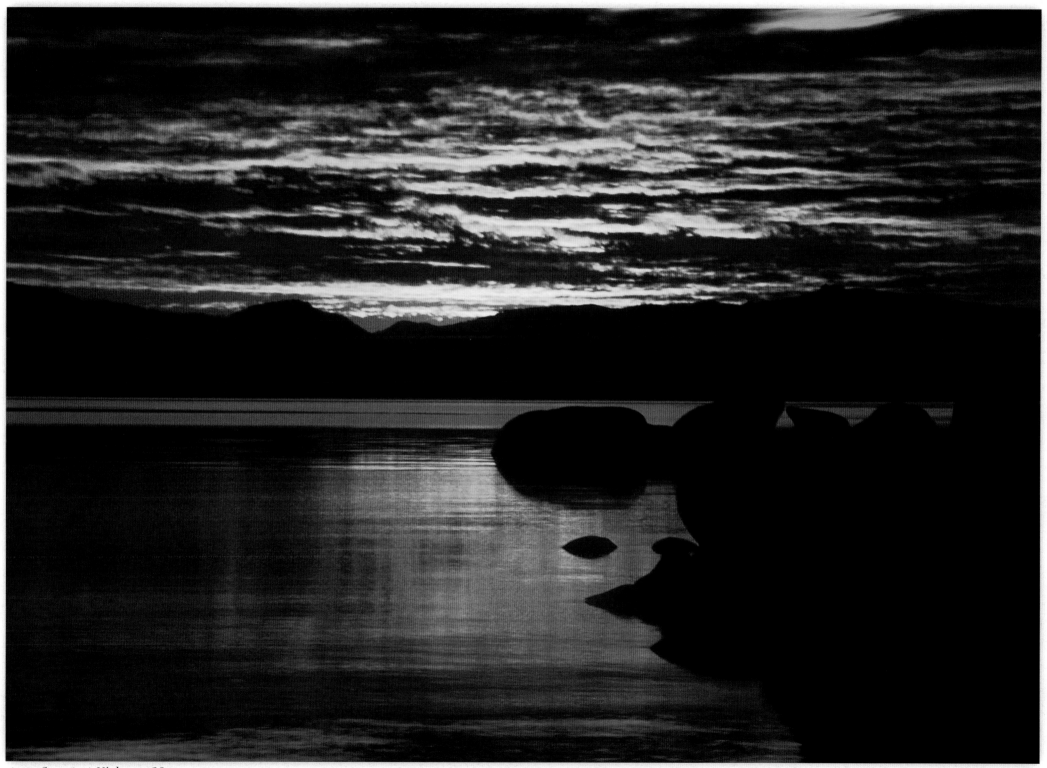

◄ **64.** *Sunset at Highway 28*

65. *Sunset at Cave Rock*

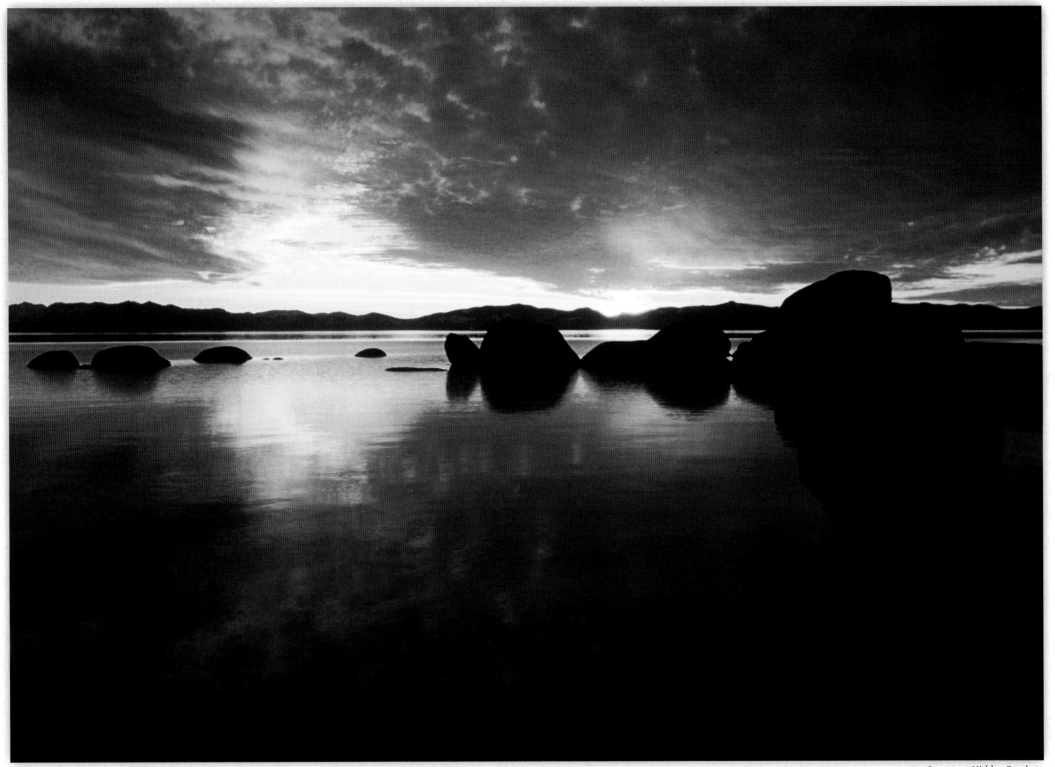

66. *Sunset at Sand Harbor*

67. *Sunset at Hidden Beach* ▶

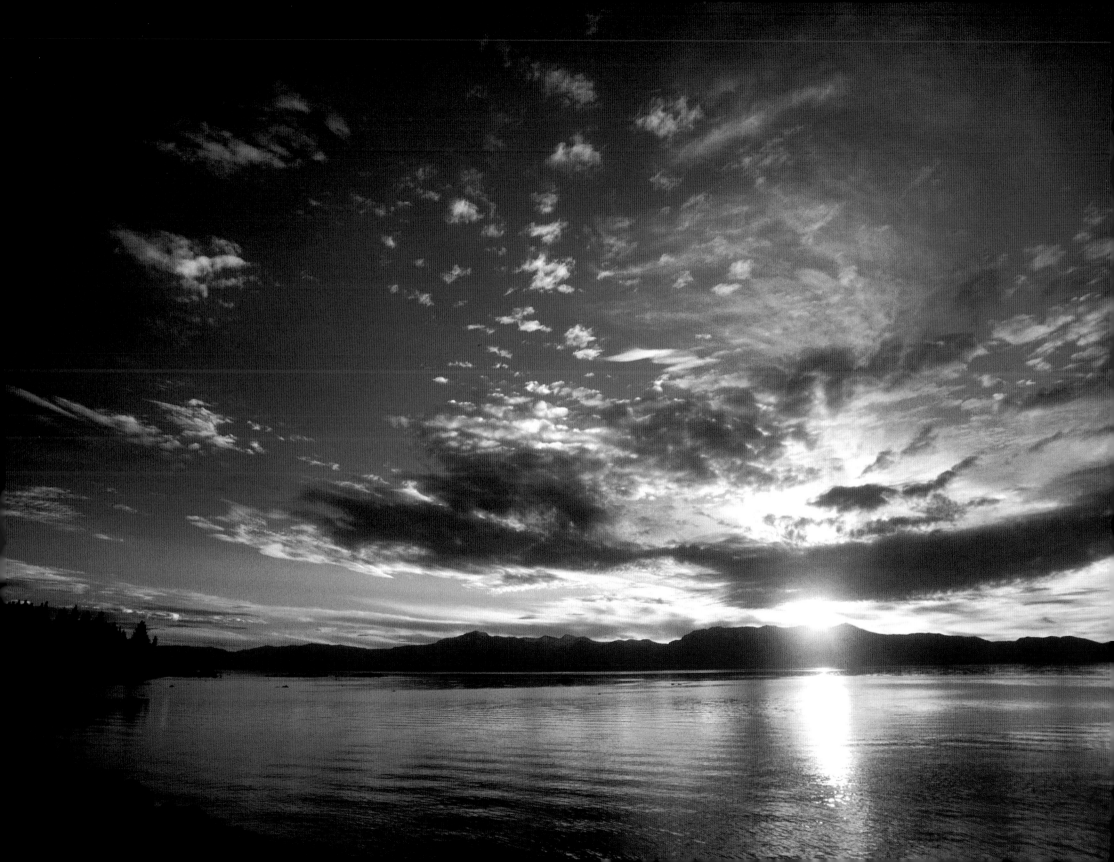

The Wildflowers

The colors and shapes, the patterns and mosaics, the single flower with its intriguing design and construction or thousands of flowers matted together so thickly that it seems that nature has gone into the carpet business. This is the world of wildflowers. Starting to bloom at lower elevations as early as March and continuing a journey as late as August in the high country, Tahoe and its surrounding area bathes itself in colors so rich and vibrant that it would be hard for any paint company to duplicate exactly the hues and saturations. As Helen Keller once said, "It is possible to know a flower, root and stem and all the processes of growth and yet have no appreciation of the flower fresh bathed in heaven's dew." Each wildflower has traveled its own renewable journey from seed to bloom. Each has overcome thousands of obstacles to create its tapestry of color. All we have to do is slow down and allow all this natural beauty to become part of our journey to Tahoe.

68. *Lupine*

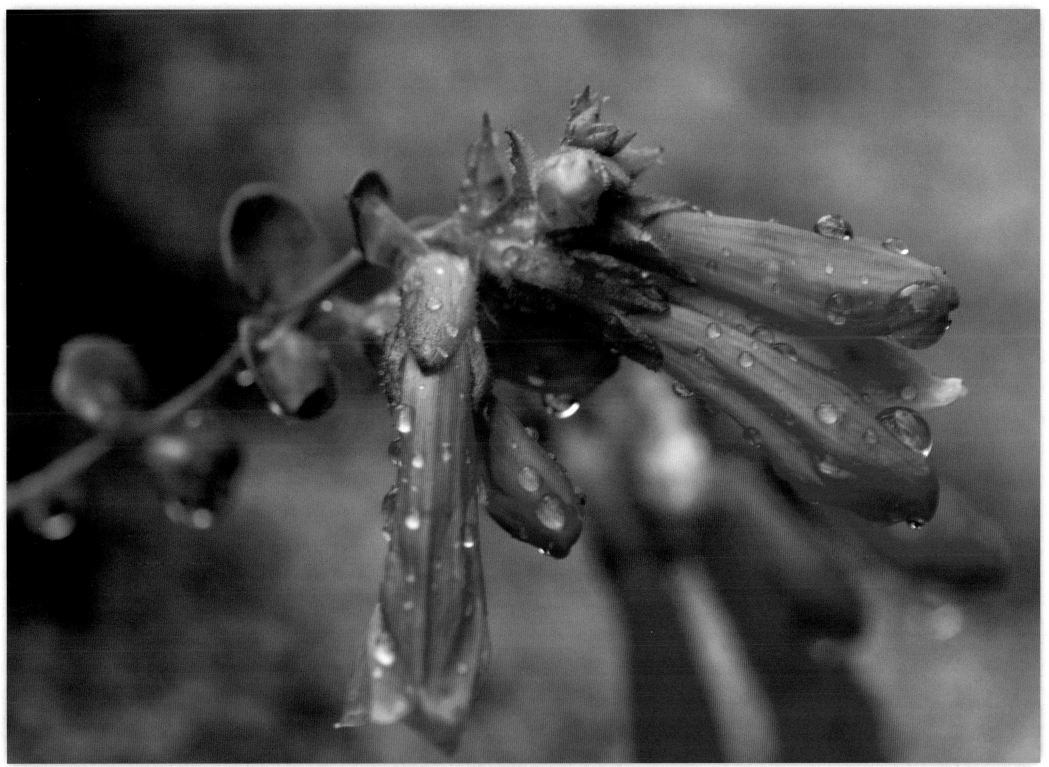

69. *Alpine penstemon*

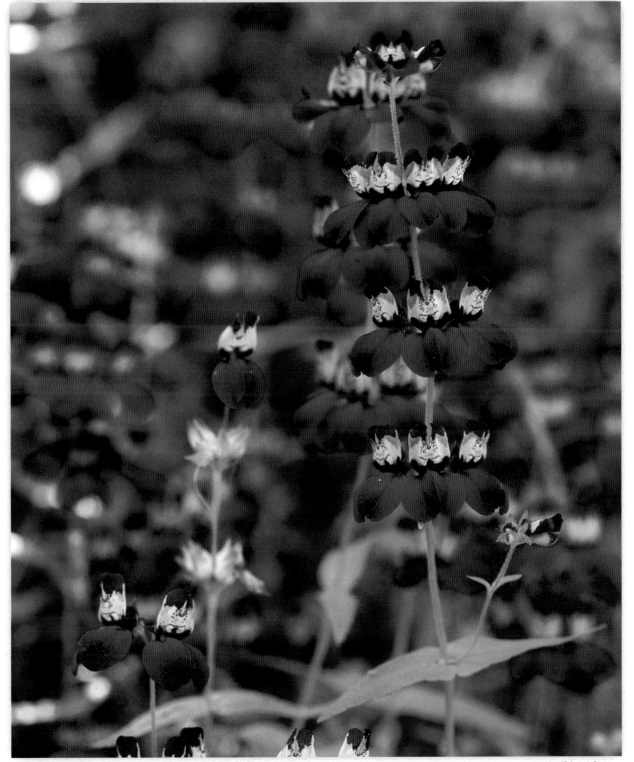

◄ **70.** *Columbine*

71. *Chinese houses*

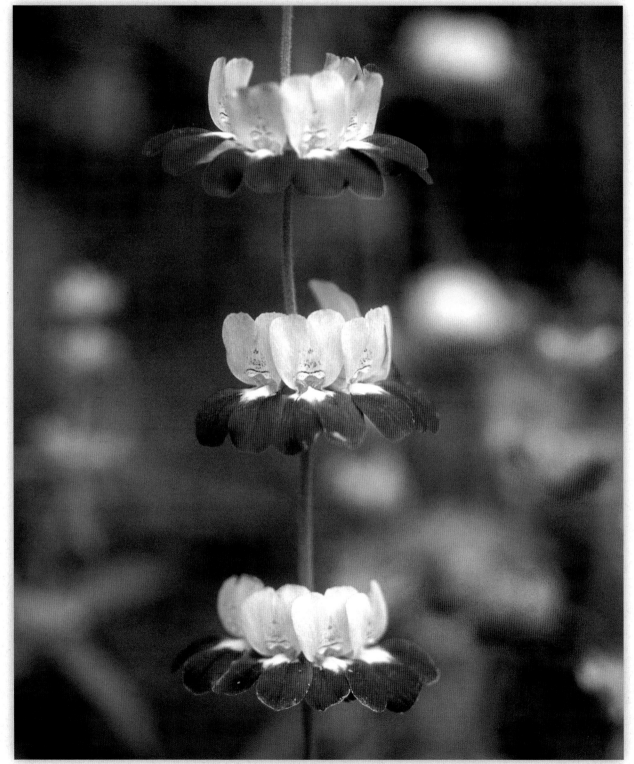

72. *Chinese house*

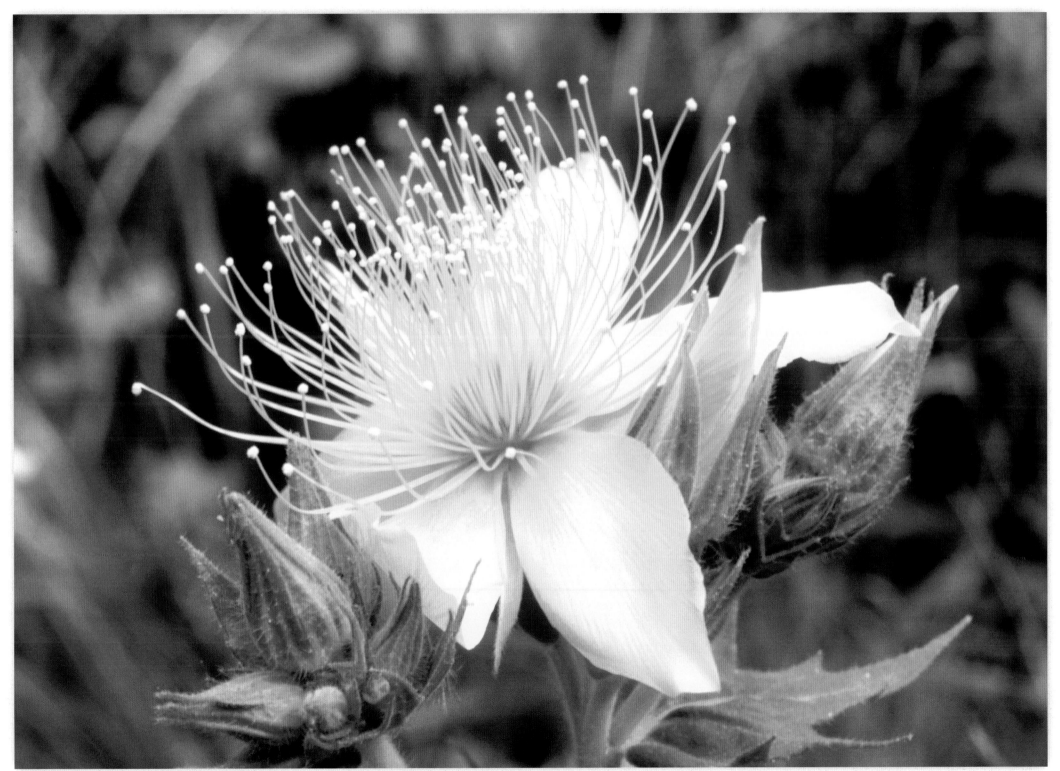

73. *Blazing star*

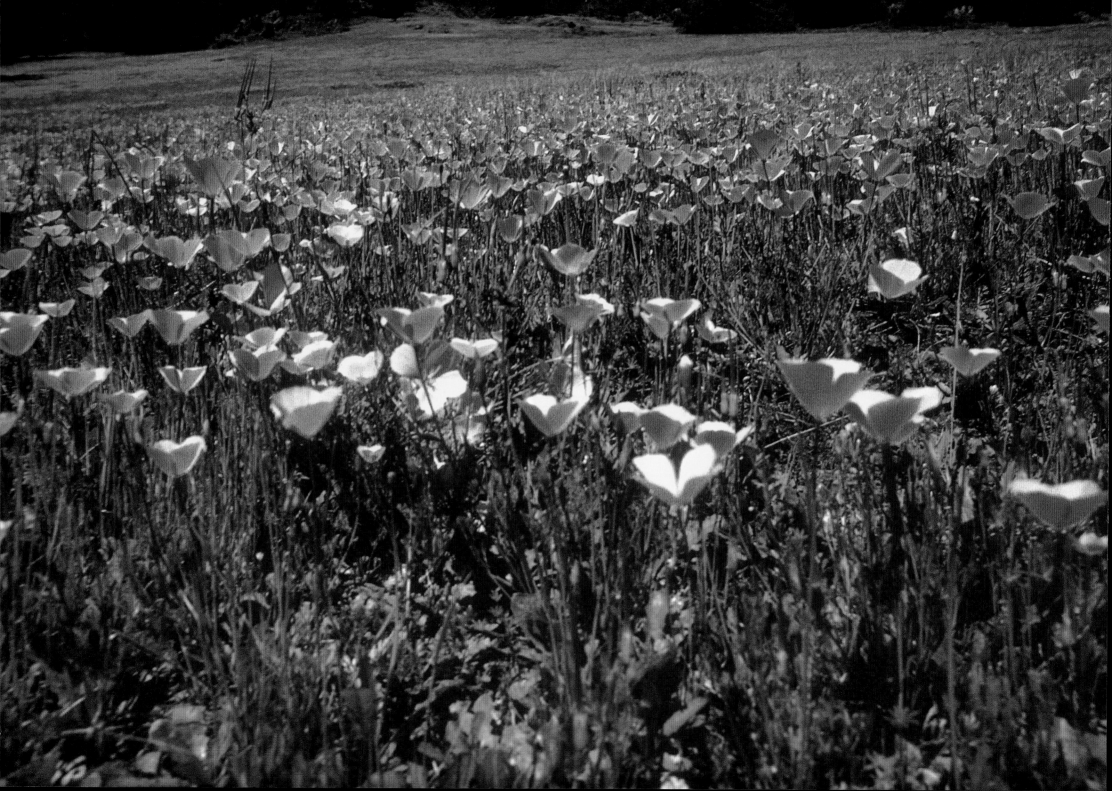

◄ **74.** *Golden poppies*

75. *Tiger lily*

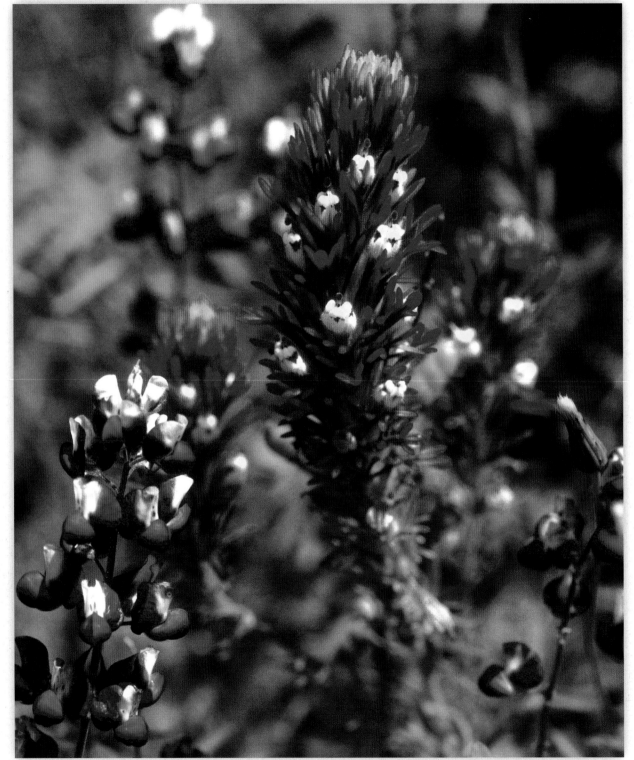

76. *Owlsclover*

77. *Wildflower mosaic* ▶ ▶

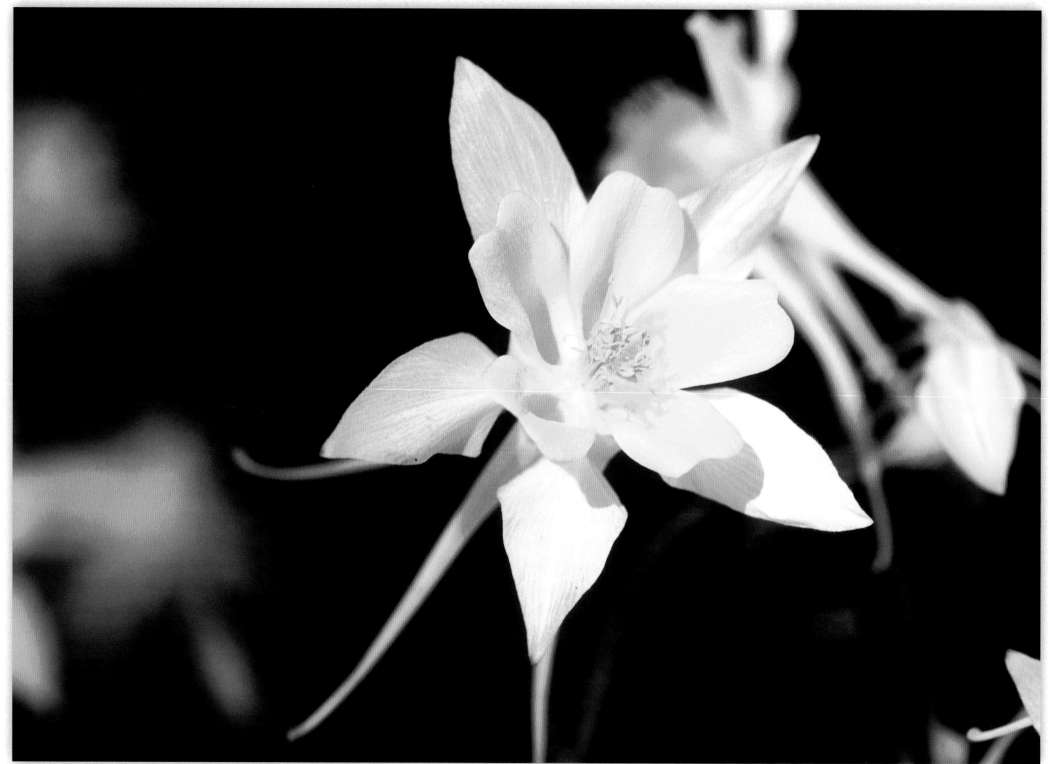

78. *Columbine*

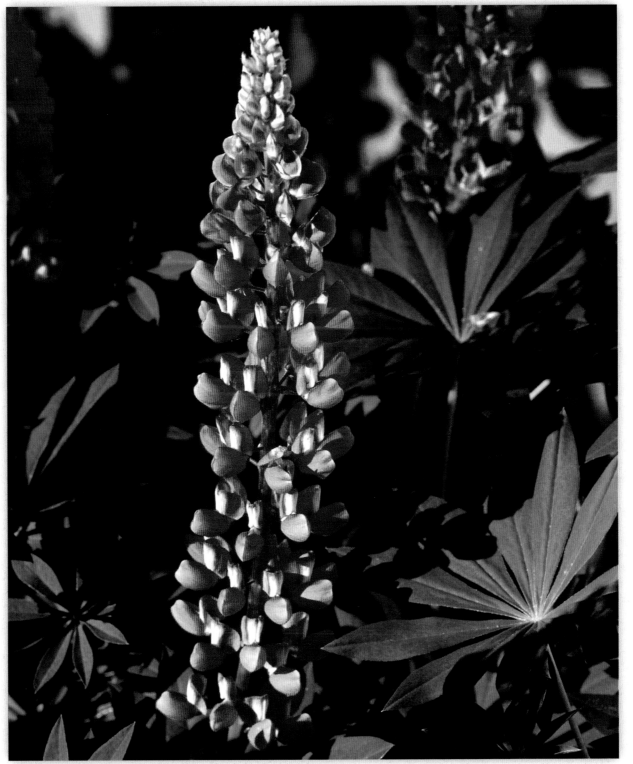

79. *Lupine*

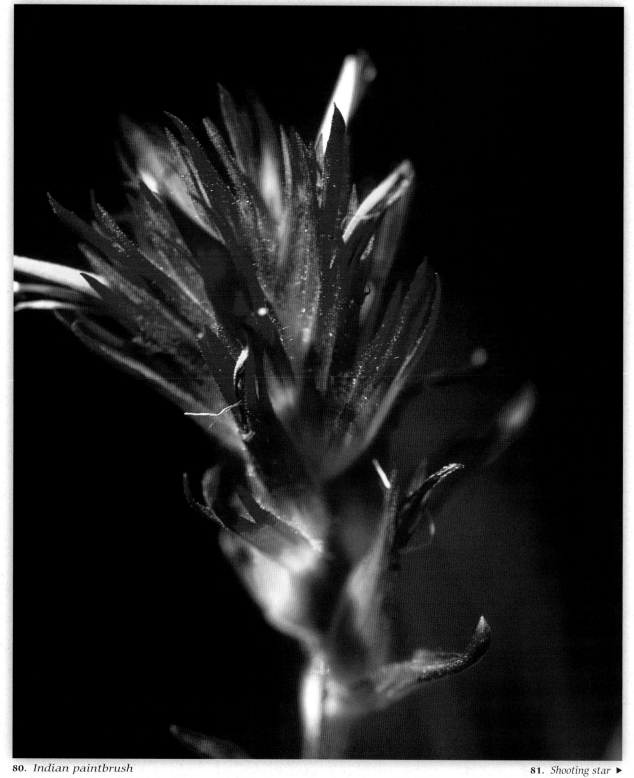

80. *Indian paintbrush*

81. *Shooting star* ▶

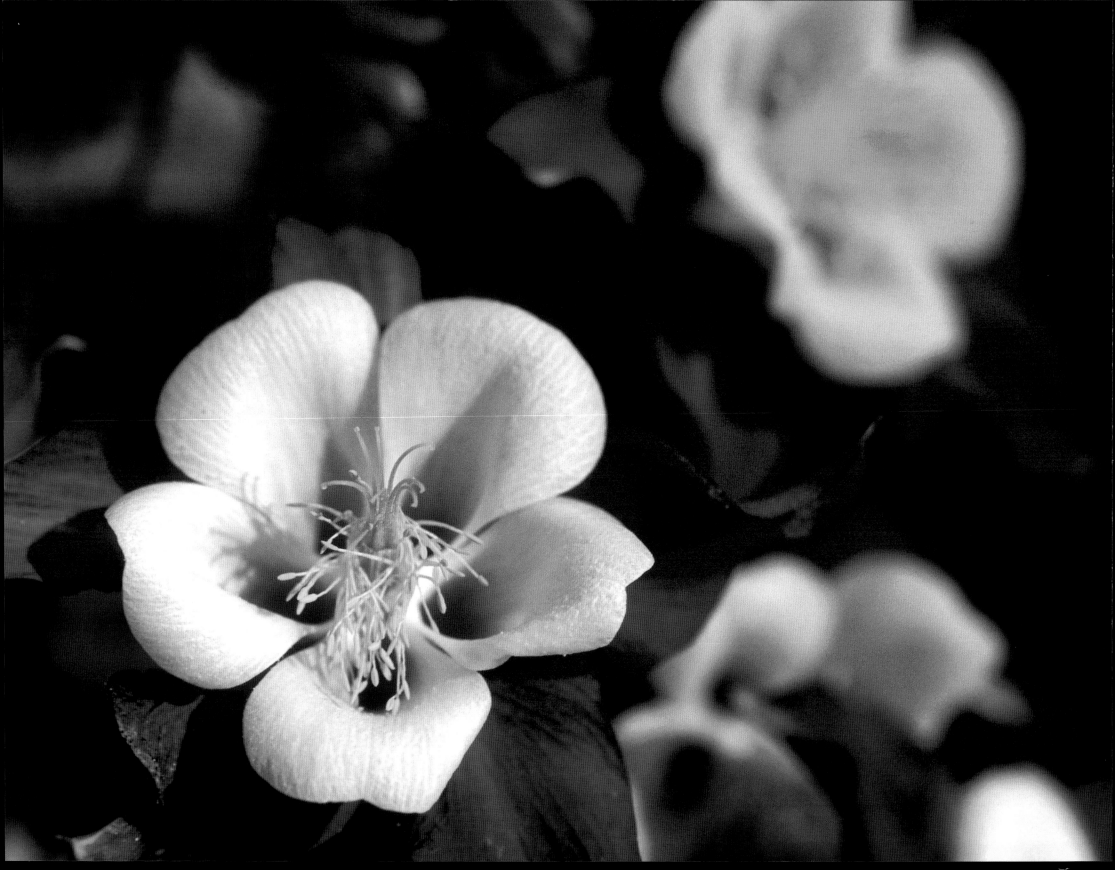

◀ **82.** *Columbine*

83. *Columbine*

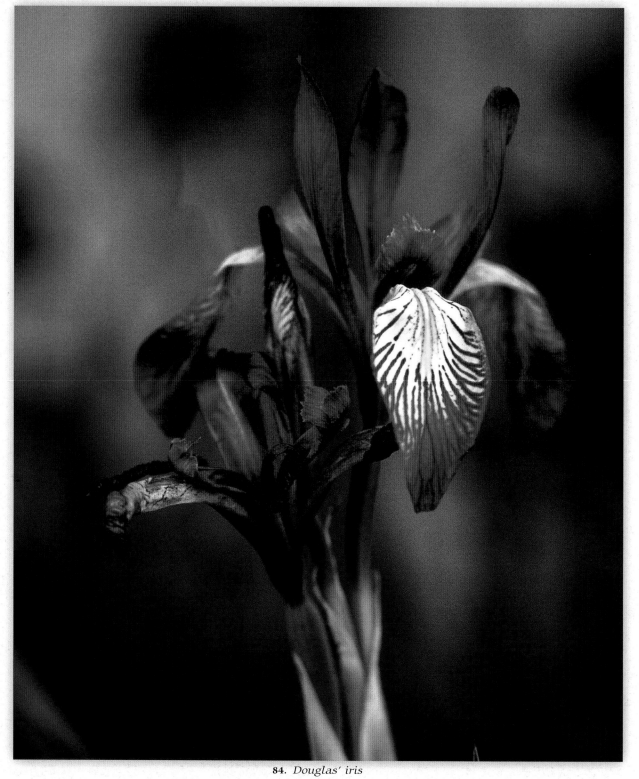

84. *Douglas' iris*

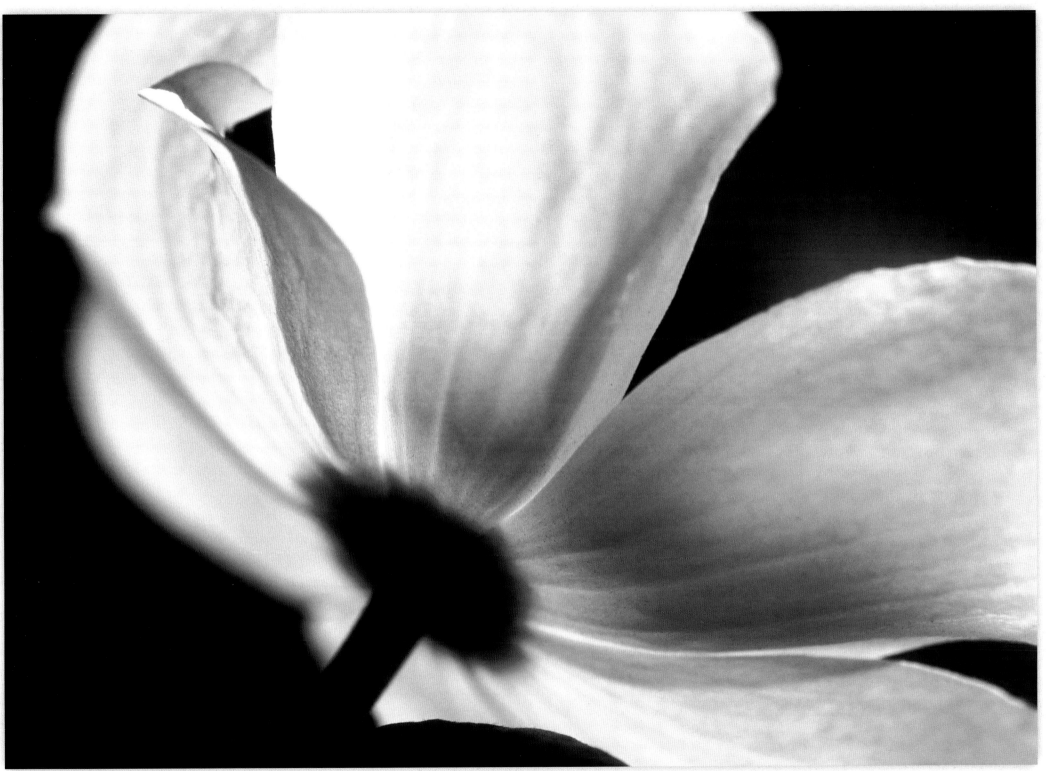

85. *Dogwood*

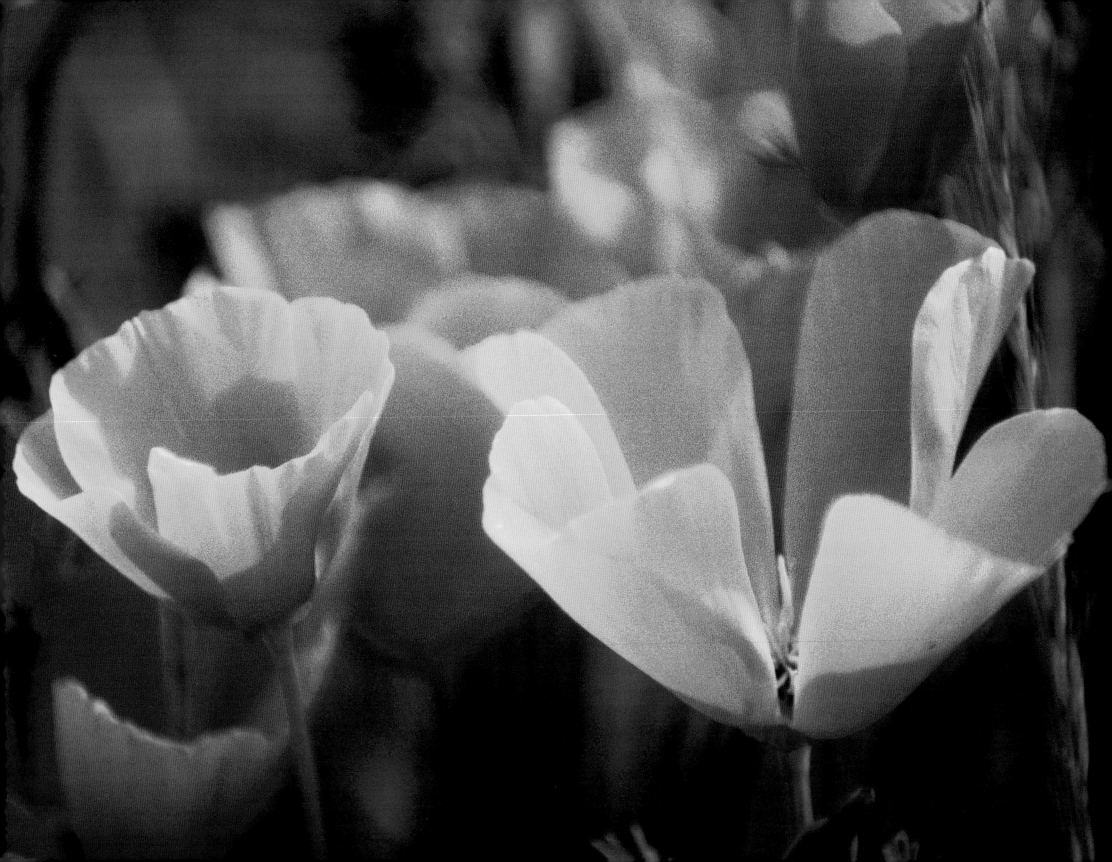

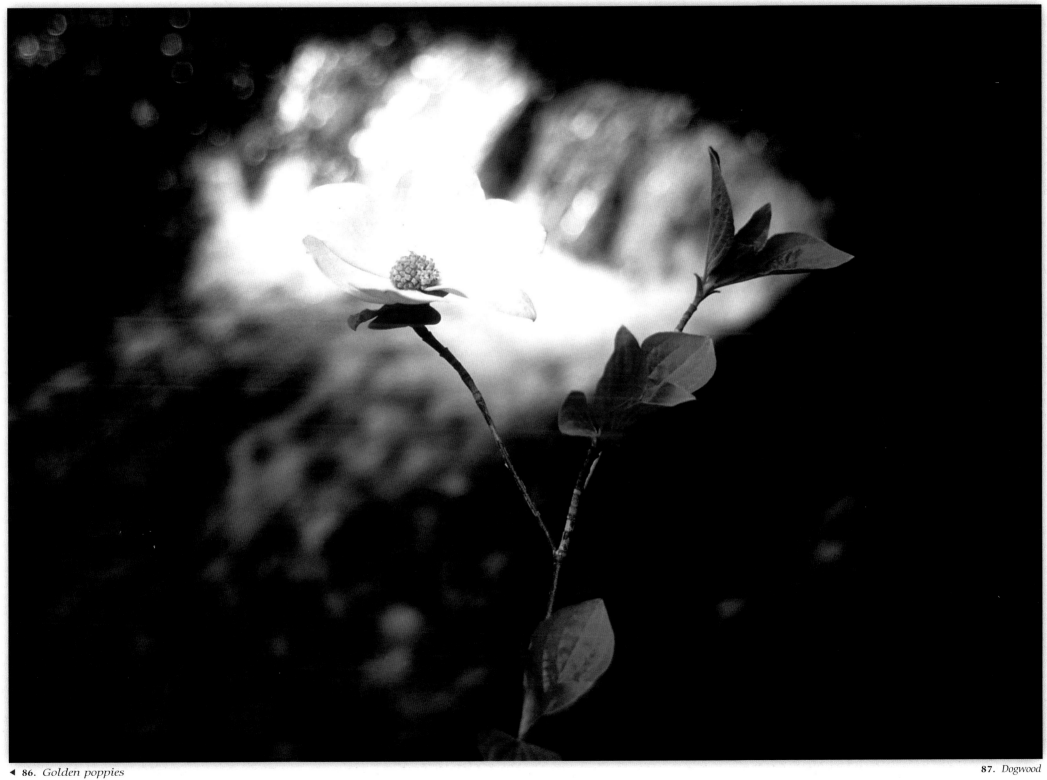

◀ **86.** *Golden poppies*

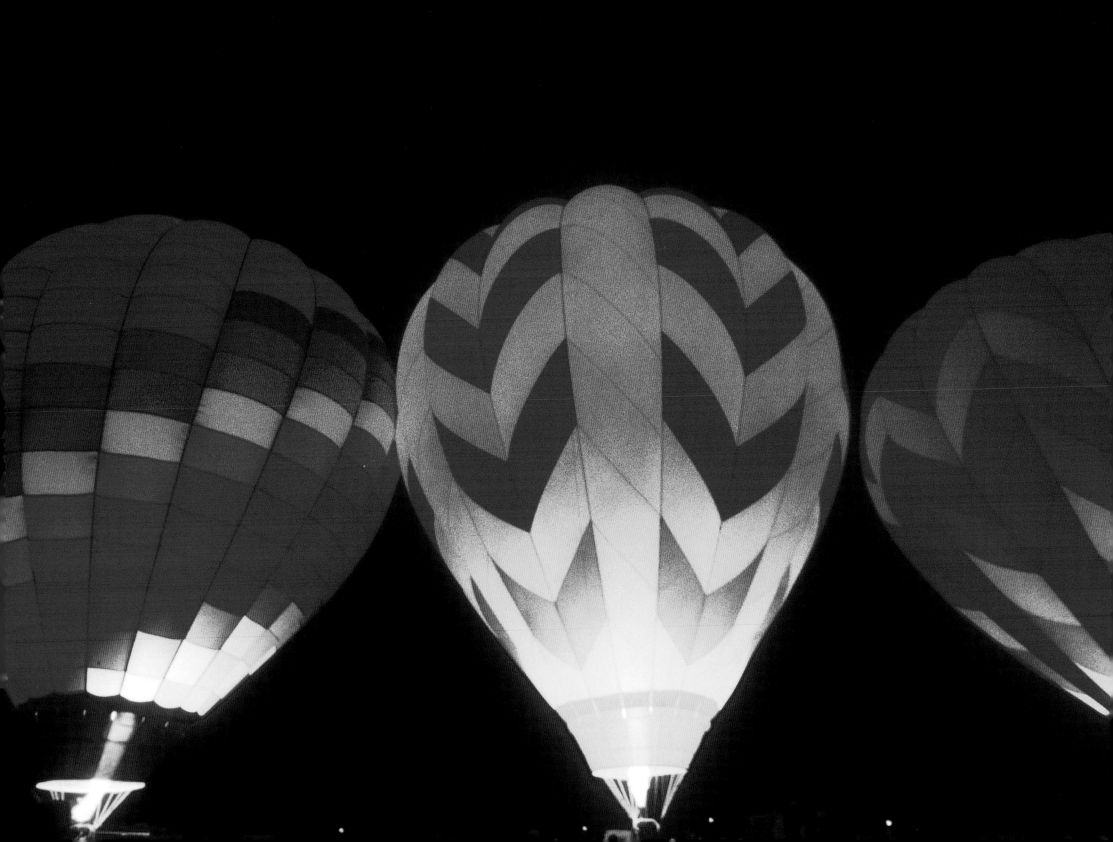

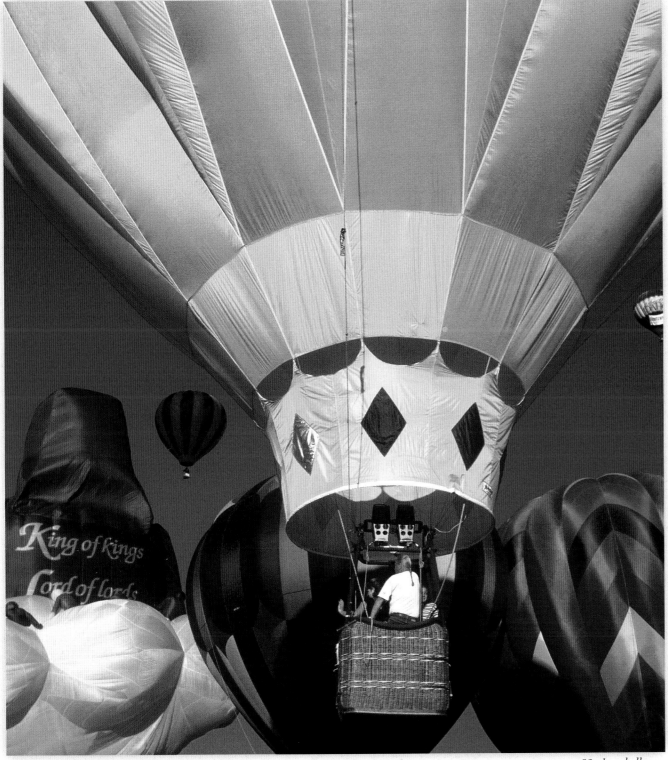

The Reno Balloon Festival

Hot air balloons have always held a special place in my heart. For well over a decade, these magical shapes have launched themselves skyward from Rancho Santa Fe Park on the weekend after Labor Day. The energy, beauty and timelessness of the Dawn Patrol and Mass Ascent allow a journey back to a simple time where the wind and not a motor determine direction and course. Sometimes we all need to feel the pull of nature and allow our journeys to go largely unplanned and at the whim of natural forces. To be truly free is to be one with the wind and not try to dominate and change it.

◄ **88.** *Dawn patrol*

89. *Lone ballooner*

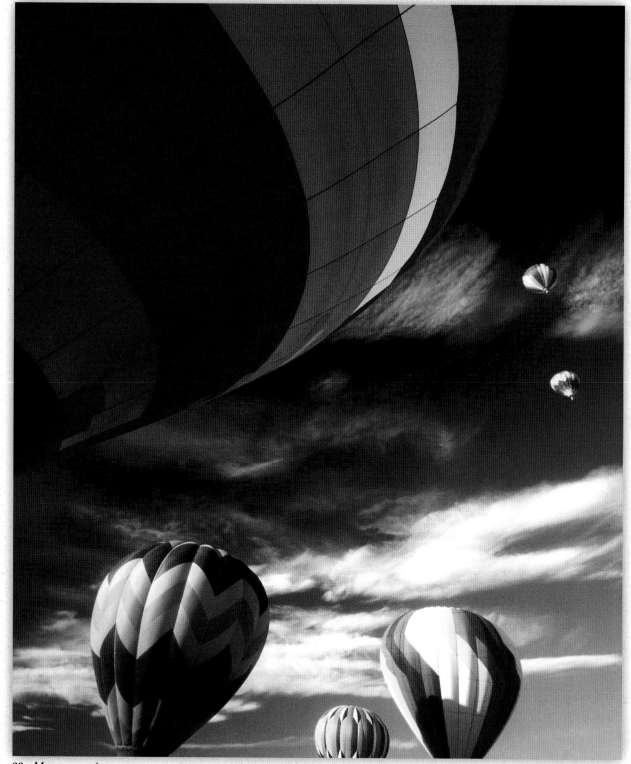

90. *Mass ascent*

91. *Mass ascent* ▶

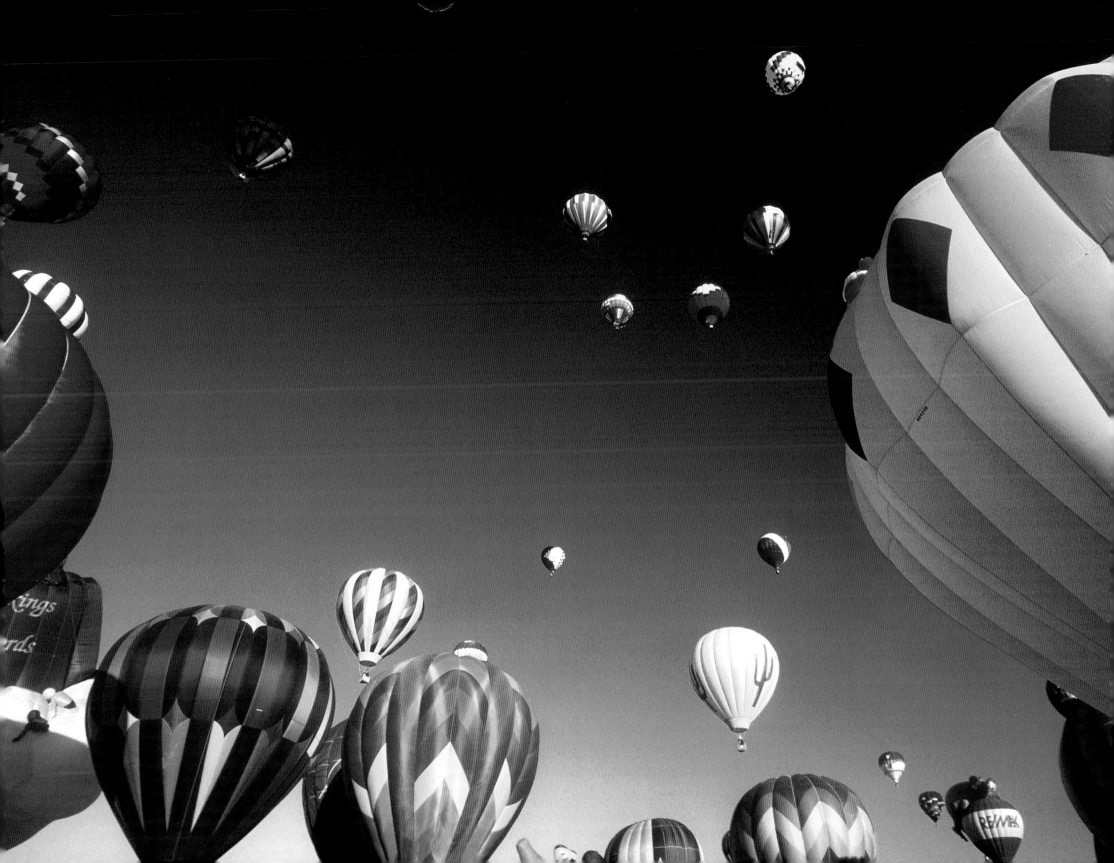

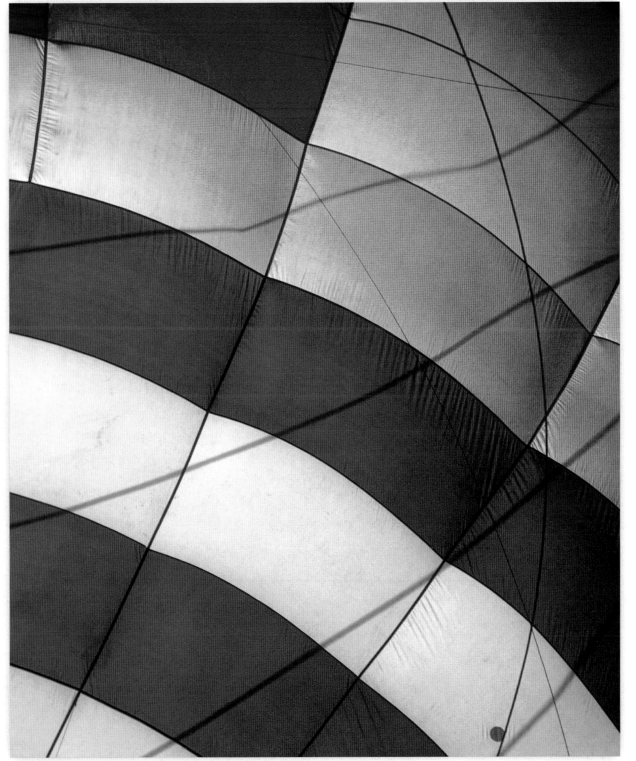

◄ **92.** *Shapes and colors*

93. *Shapes and colors*

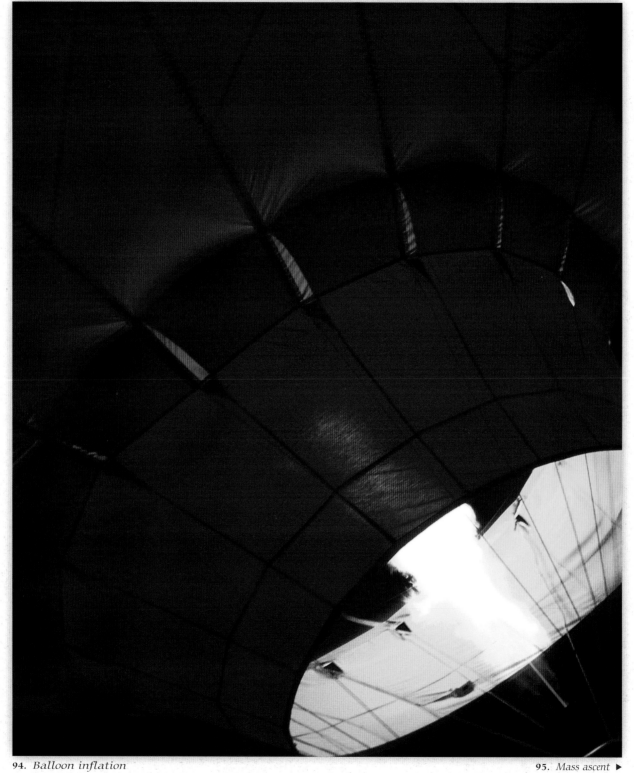

94. *Balloon inflation*

95. *Mass ascent* ▶

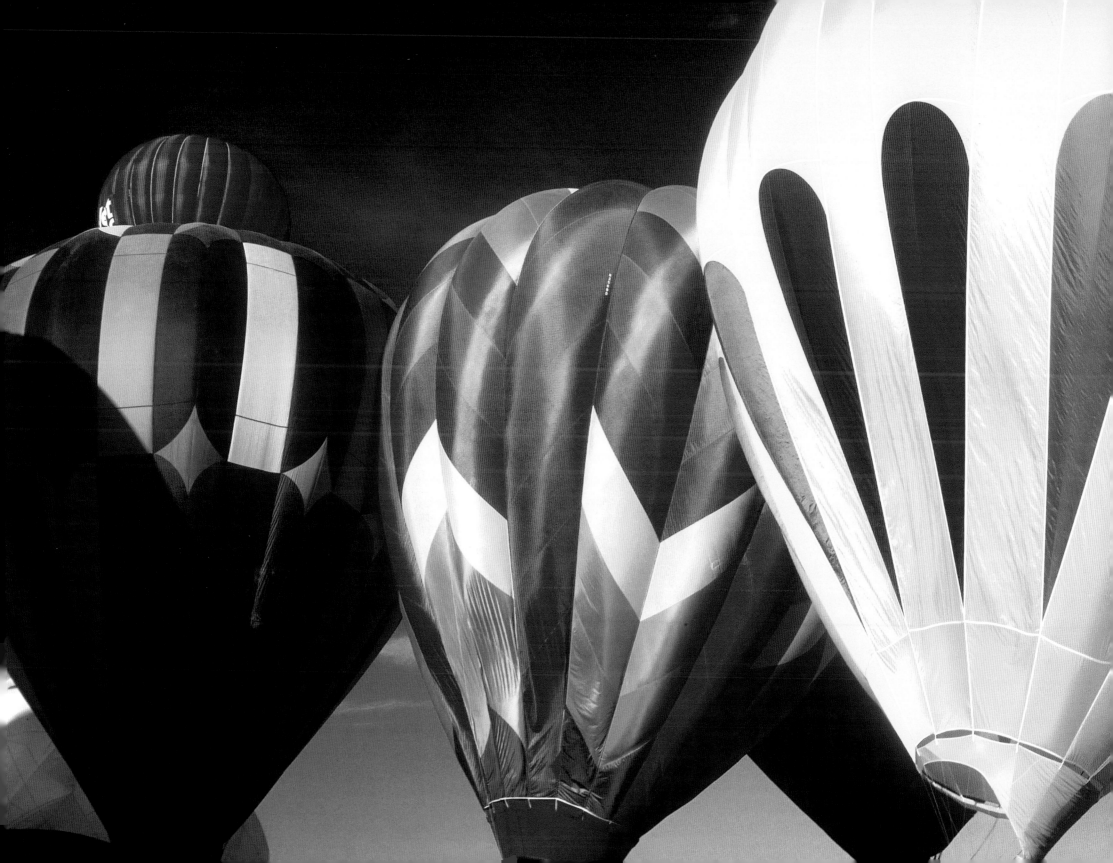

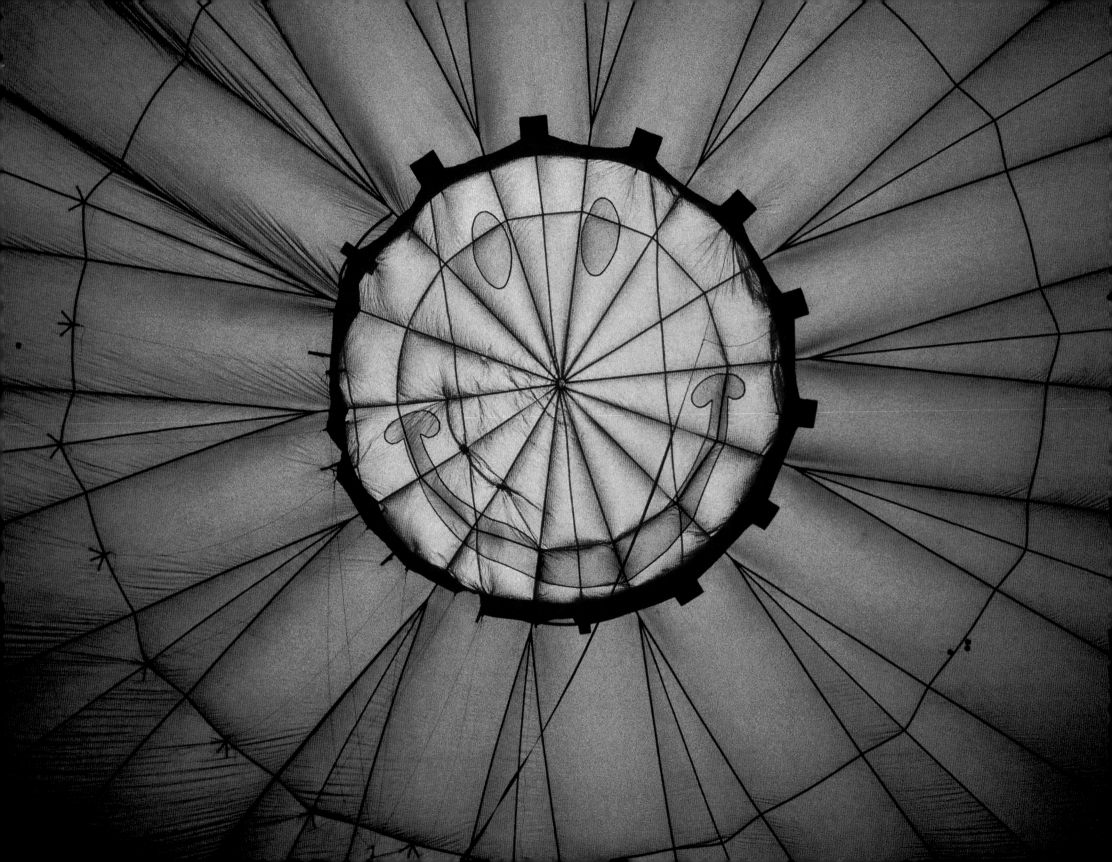

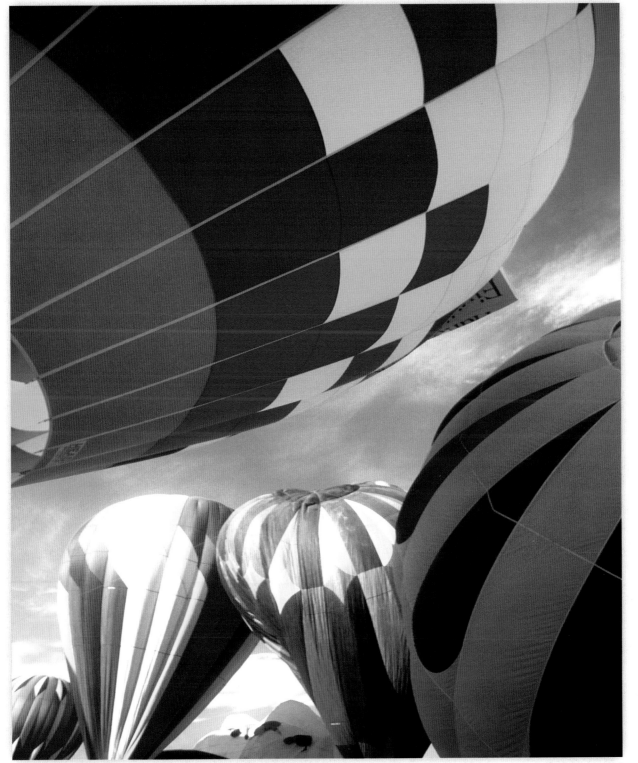

◀ **96.** *Shapes and colors*

97. *Mass ascent*

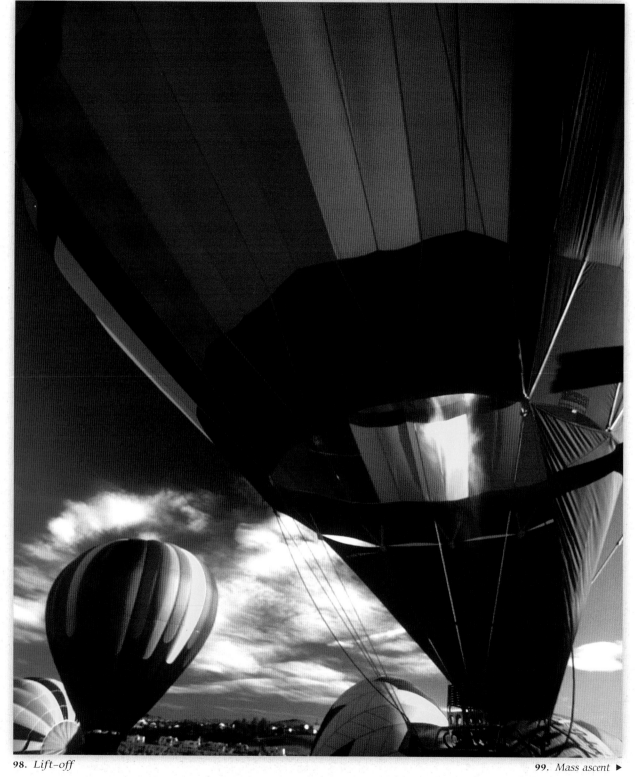

98. *Lift–off*

99. *Mass ascent* ▶

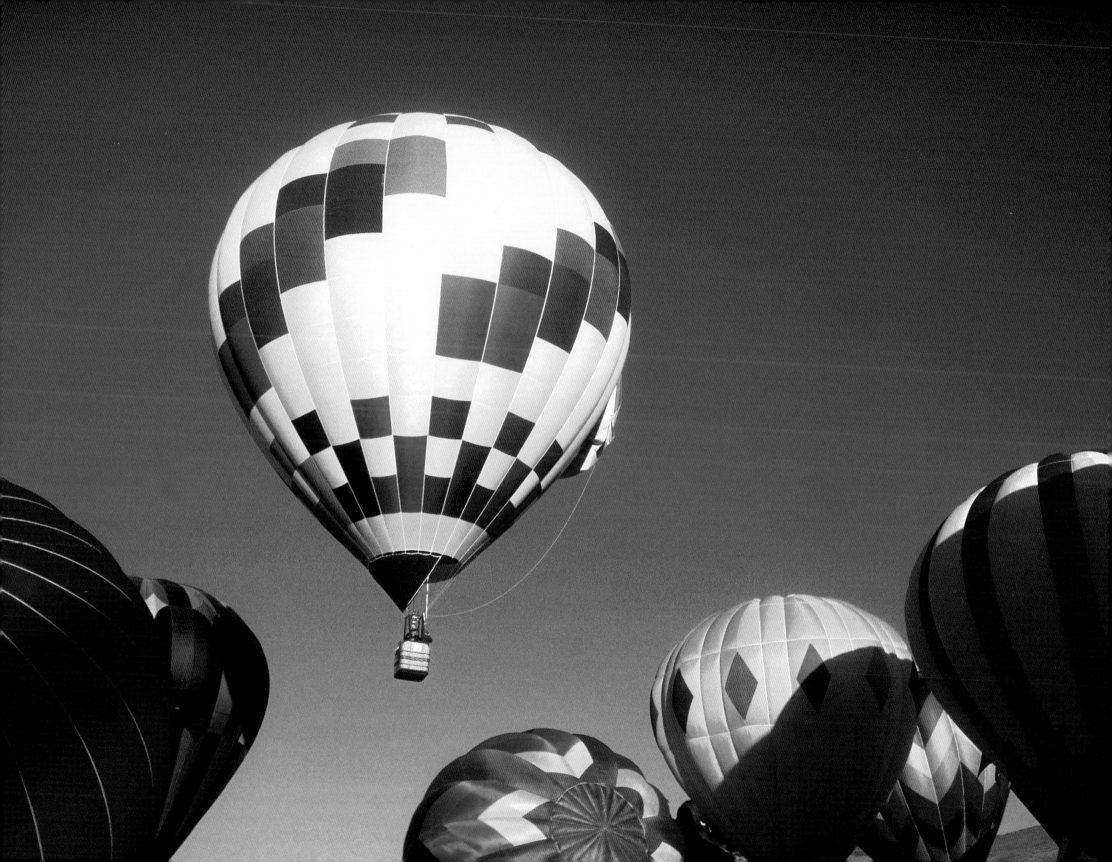

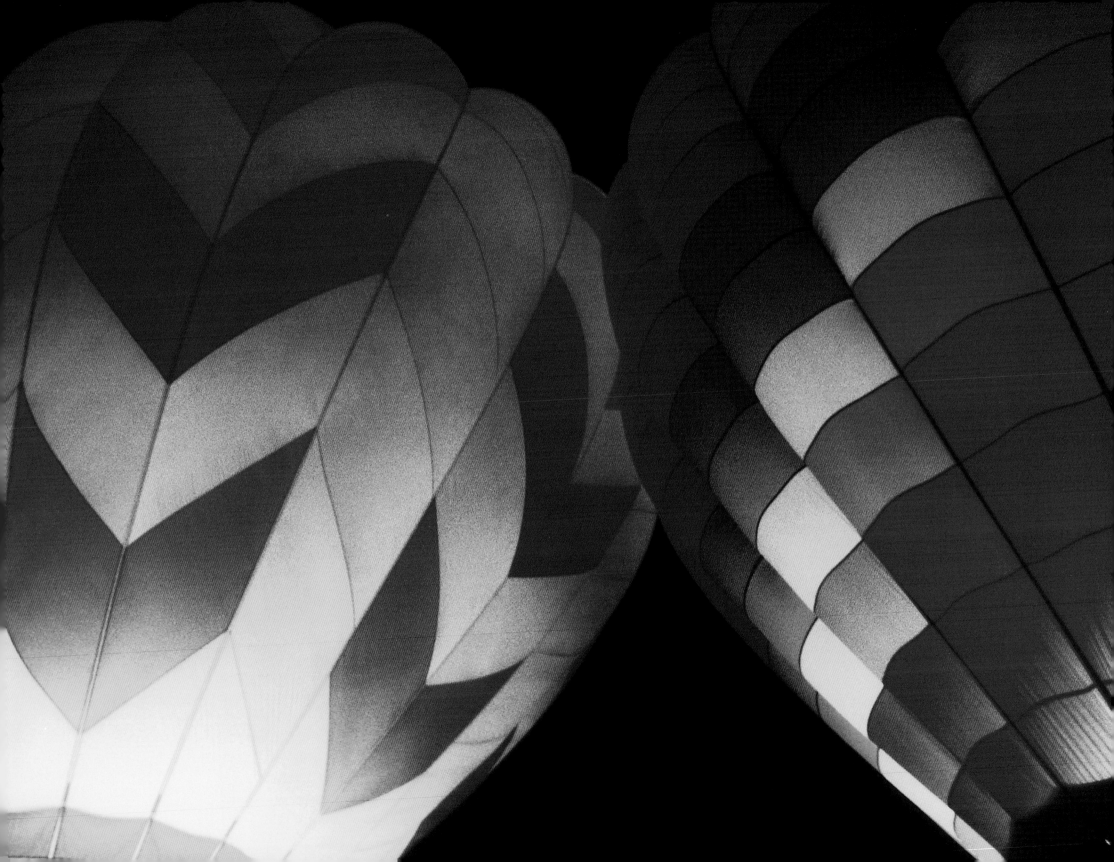

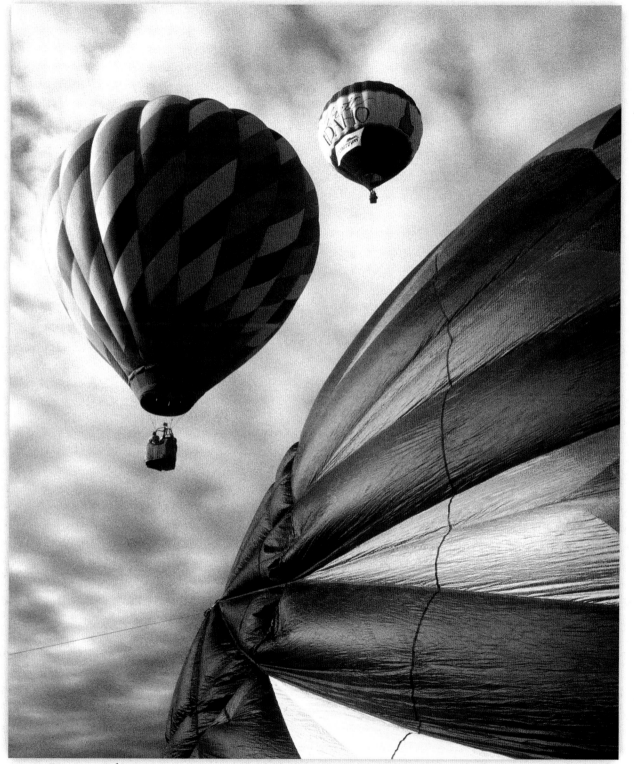

◄ **100.** *Dawn patrol*

101. *Mass ascent*

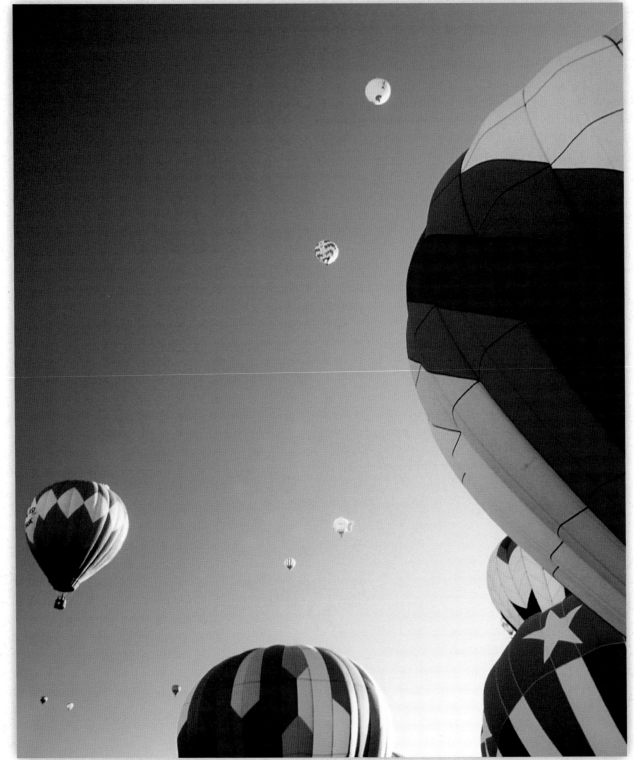

102. *Lift–off*

103. *Mass ascent* ▶

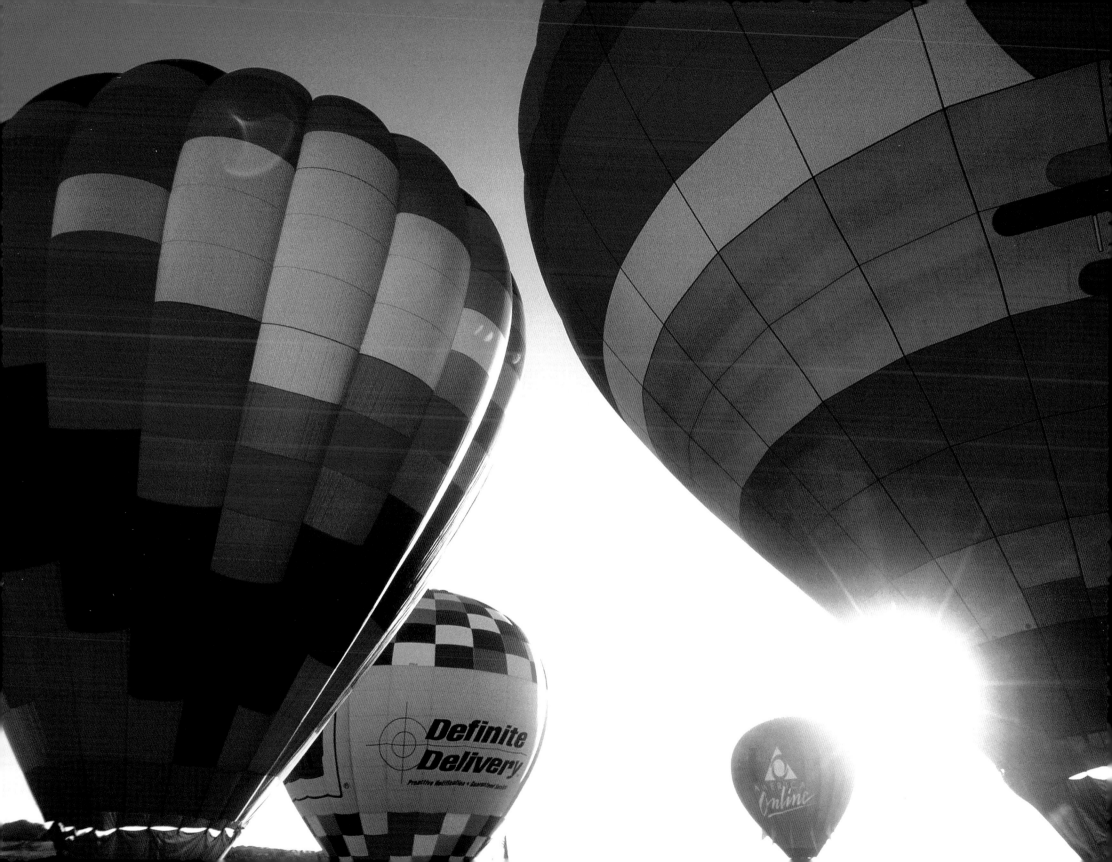

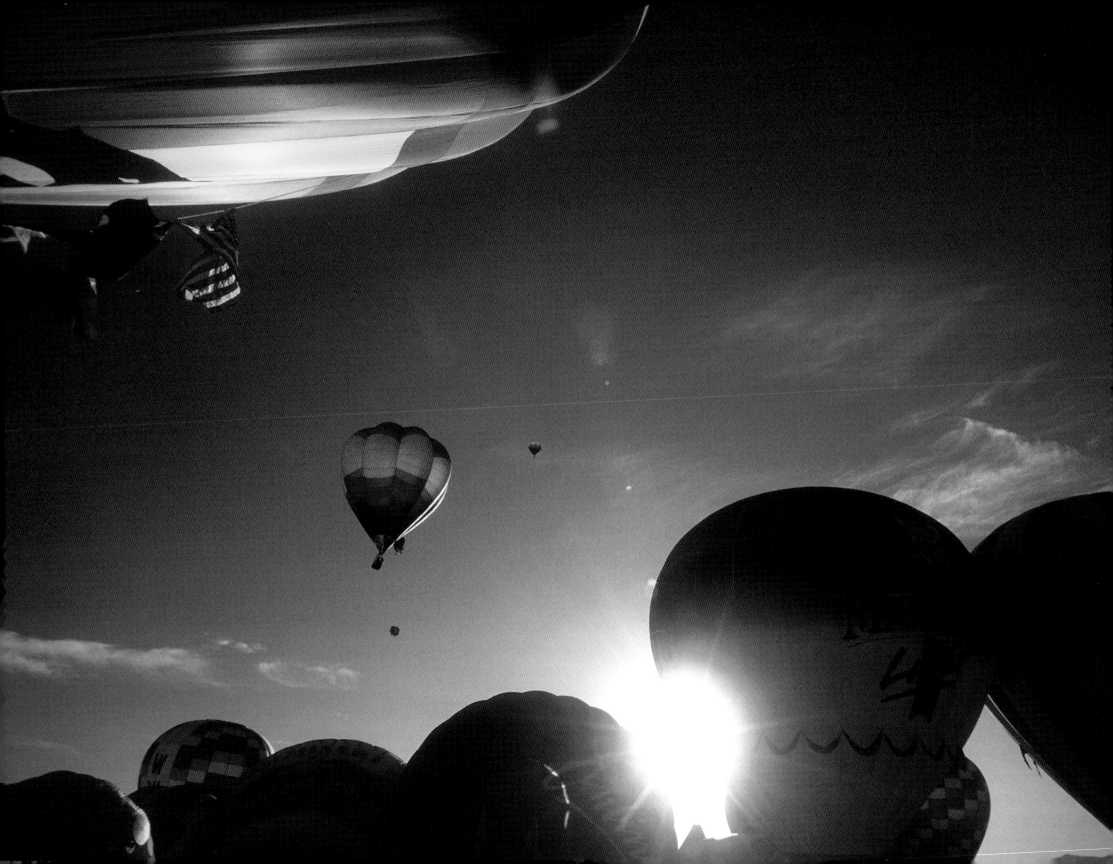

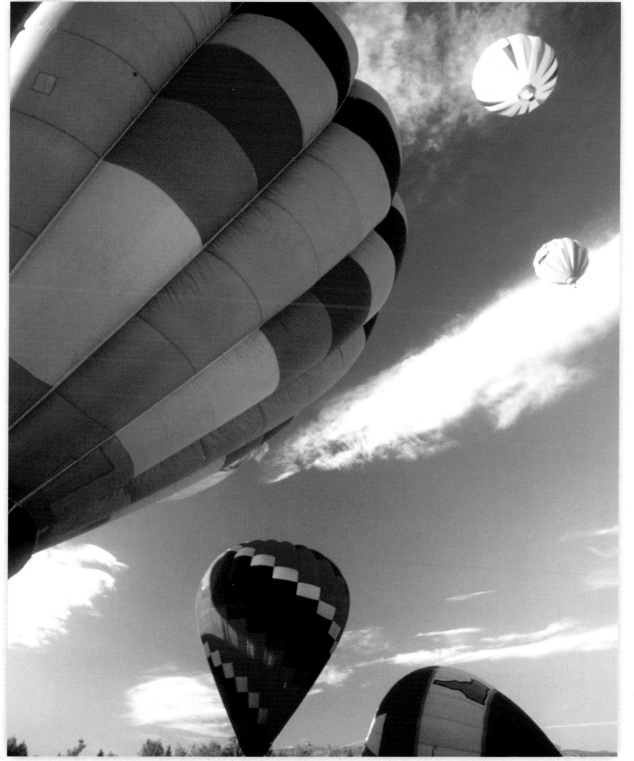

◄ **104.** *Sunrise*

105. *Mass ascent*

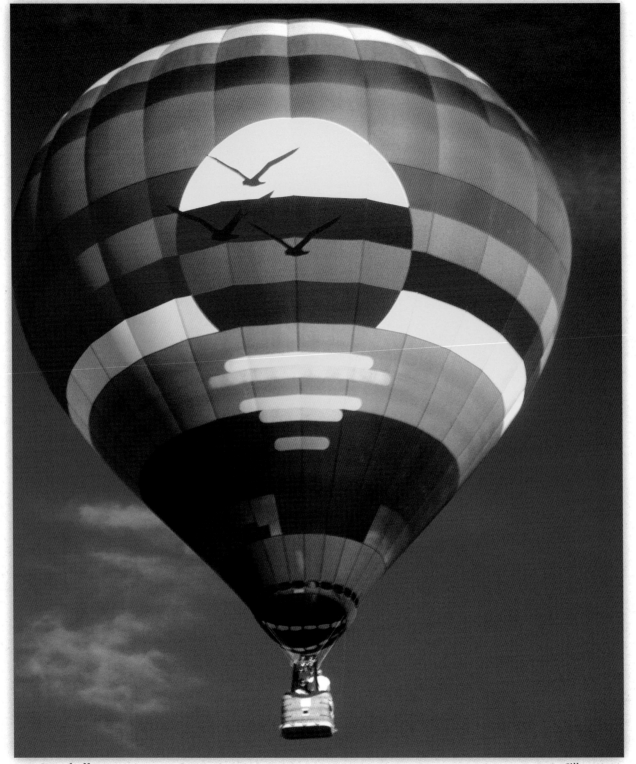

106. *Lone ballooner*

107. *Silhouettes* ▶

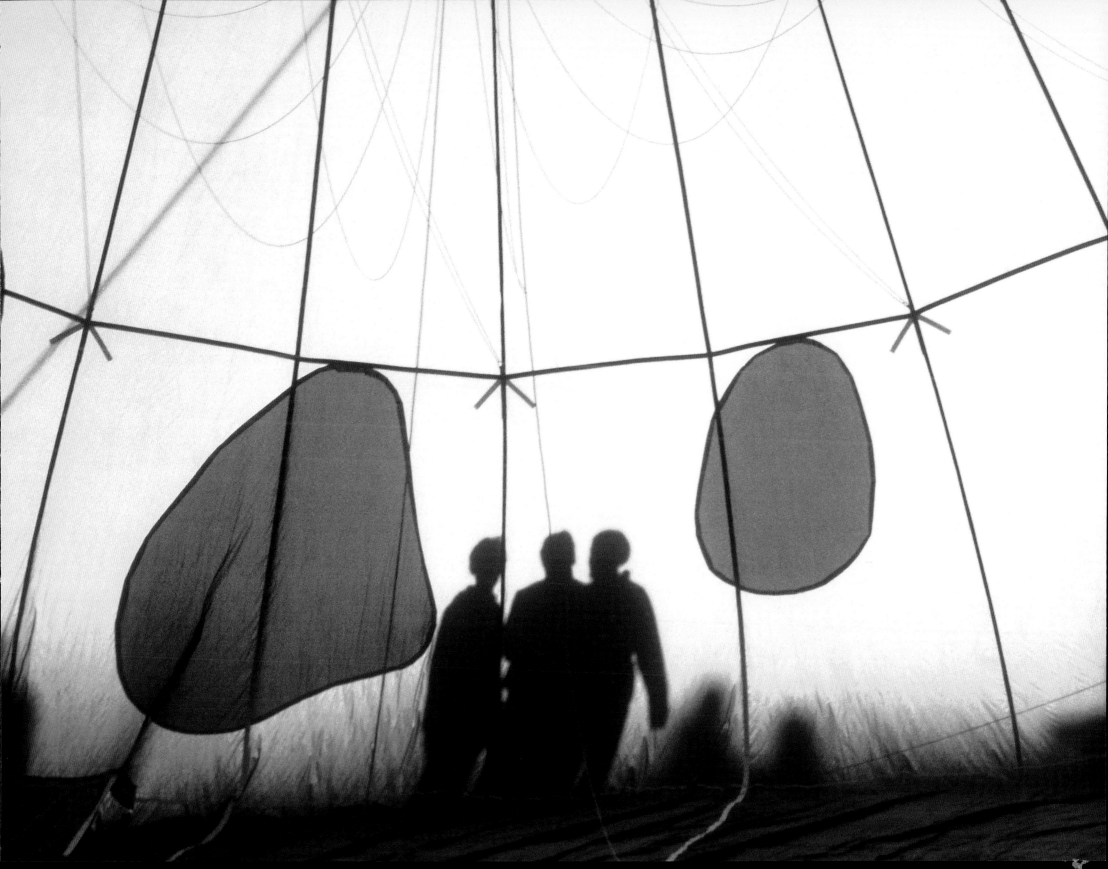

List of photographs

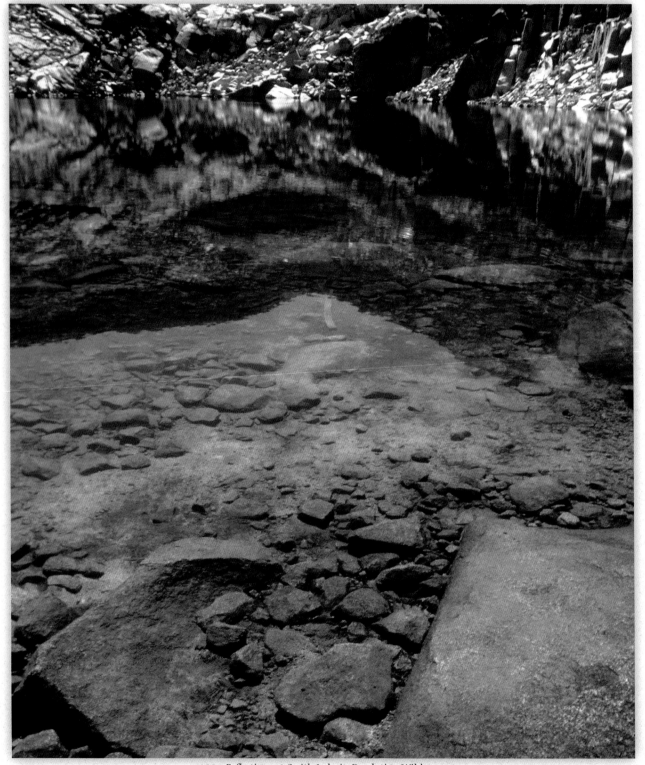

108. *Reflections at Smith Lake in Desolation Wilderness*

Acknowledgements

Art Director

Andrew Garcia

Editing

Loretta Pesetski

Kathlee Coleman

Frank Wright

Editor In Charge of Production

Frank Wright

Publication

Sierra Vista Publishing

Printing

Asia Pacific Offset Ltd.

Special Thanks to:

I want to dedicate this work to my good friends Satish, Indar, Steve, Kitty, Marta, and Dorothy, who helped me see the beauty in the world; to Frank, Lisa, David, and Andrew who helped make this project possible; to Bob and Sharon who showed me how the human spirit can overcome tragedy and emerge stronger and more resilient than ever; to my fellow journeymen Brian and Judie for their love and support; to my four-legged friends Linus, Snoopy, Woody, Patty, and Lucy, whose unconditional love and companionship allowed the magic of image creation to happen; and finally to my wife, Loretta, who has seen these sights with me, who has inspired the images you see and whose love has allowed my personal journey to Tahoe and beyond to be happy and fulfilled beyond my wildest hopes and dreams.

Larry Pesetski has spent a lifetime capturing breath-taking photographic images of the most beautiful and unique areas of America. The Lake Tahoe region and the Yosemite Valley have been his most favored venues. Larry has photographed much of the Sierra Nevada Mountains and the Big Sur Pacific Coastline.

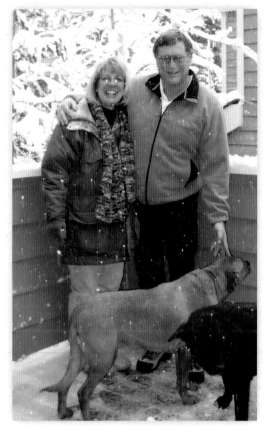

Larry's images have appeared on numerous calendars, greeting cards and visitor's bureau literature. The Fresno California Visitors and Convention Center uses Larry's images to publicize the Blossom Trail in the Central California Valley. Larry is a member of the North American Nature Photographers Association, Yosemite Western Artists and the American Film Institute.

Larry is an educator for aspiring young photographers, teaching for many years at the high school and college levels. Larry has collaborated with some of the top animators in Hollywood. His students have produced many of the public service videos used by the United States Park Service and the California Transportation Department.

Larry's future projects include a Photographic Essay of the Yosemite Valley, The Great Reno Balloon Festival, and the beauty of the Big Sur Coastline.

Larry's wife Loretta, who shares his passion of the great outdoors, often joins him on his photograghic journeys. Larry and Loretta split their time between Incline Village, Nevada and Oakhurst, California.

You can view Larry's images on his web site: www.lllphotography.com.

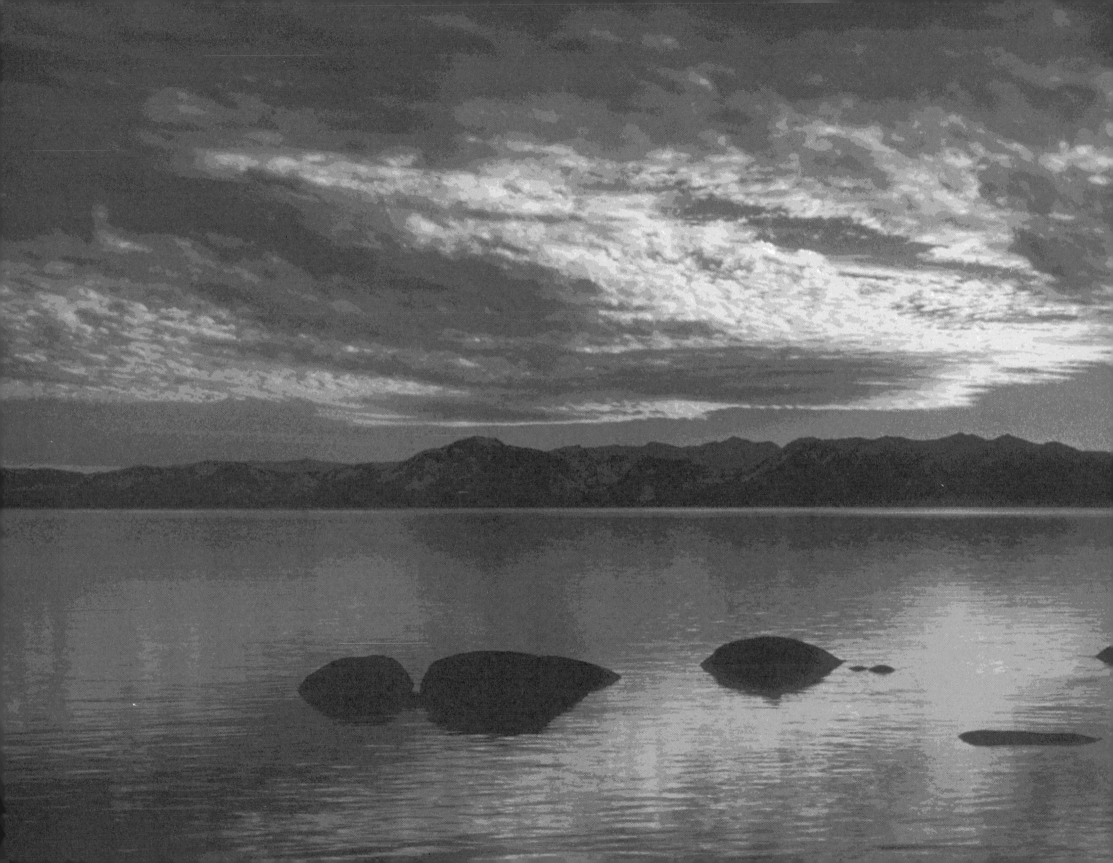